THE MAGEN DAVID

The Magen David: How the Six-Pointed Star Became an Emblem for the Jewish People is the inaugural volume in the David M. Blumberg Library, a perpetual book publishing program honoring the memory of B'nai B'rith's International President from 1971 to 1978.

Manuscripts selected for publication in the Blumberg Library are outstanding literary works which seek to promote a greater popular understanding of Judaism, the Jewish tradition, and the rebirth in the twentieth century of a Jewish State in the Land of Israel.

The sponsors of the Blumberg Library are men and women who benefitted from the life and work of David Blumberg. They wish to create a living memorial which will enrich the lives of the generations to come after them. Let them know that B'nai B'rith had a leader who gave his whole heart and spirit to the welfare of the Jewish People, and with his great love of young people, he had the wisdom to know that one cannot ask a rising generation to embrace their Jewish heritage without first understanding it.

<div align="center">

David M. Blumberg

1911–1989

זכרנו לברכה

May his memory serve as a blessing.

Patrons of the David M. Blumberg Library

Lester and Susan Crown
Joseph H. and Jacqueline Domberger
Billy B. and Rosalie Goldberg
Erwin S. and Genevieve S. Jaffe
Hon. Philip M. and Ethel Klutznick
Gerald R. and Adele Kraft
Moe and Berdie Kudler
Alan B. and Charna Larkin
Philip and Mildred Lax
Milton T. and Helen G. Smith
Jack J. and Charlotte B. Spitzer
Fred S. and Della Worms

</div>

THE MAGEN DAVID

How the six-pointed star became an emblem for the Jewish people

W. Gunther Plaut

B'nai B'rith Books
Washington, D.C.

Jerusalem • London • Paris • Buenos Aires • East Sydney

Library of Congress-In-Publication Data

Plaut, W. Gunther, 1912–
 The Magen David: how the six-pointed star became an emblem for
the Jewish people/W. Gunther Plaut.
 p. cm.
 Includes bibliographies.
 ISBN 0-910250-16-2
 1. Magen David. I. Title.
BM657.5.M3P43 1989 89-15433
296.4—dc19 CIP

Dedicated to those

who did not survive to see the Magen David

become the ensign of life.

Also by W. Gunther Plaut

NON-FICTION
Die materielle Eheungültigkeit (doctoral dissertation, 1934)
High Holiday Services for Children (1952)
Mount Zion — the First Hundred Years (1956)
The Jews in Minnesota (1959)
The Book of Proverbs — A Commentary (1961)
Judaism and the Scientific Spirit (1962)
The Rise of Reform Judaism (1963)
The Growth of Reform Judaism (1965)
Your Neighbour is a Jew (1967)
Page Two (1971)
Genesis — A Commentary (1974)
Time to Think (1977)
Numbers — A Commentary (1979)
The Torah — A Modern Commentary (editor and principal author, 1981)
Unfinished Business (autobiography, 1981)
Refugee Determination in Canada (1985)

FICTION
Hanging Threads (short stories, 1978; published in the U.S. under the title The
 Man in the Blue Vest and other Stories)
The Letter (novel, 1986)
The Man Who Would Be Messiah (novel, 1988)

CONTENTS

Preface.. 1

Prologue: The Search.................................... 3

Form and Name... 7

A Universal Sign.. 13

Early Appearances in the Jewish Realm........................... 25

Absence and Opposition.............................. 33

Solomon and David.................................... 37

Mystical Musings...................................... 47

The Prague Connection............................... 51

The Magen David in Vienna............................. 61

The Printed Page... 65

Exit Pentagram... 71

Toward a National Symbol............................. 75

Interpretive Intermezzo................................. 81

Flag of Zion.. 87

Mark of Death — Mark of Life......................... 97

Epilogue: Star's Journey................................ 105

LIST OF ILLUSTRATIONS

Section of grillwork from the Cikánova Synagogue
 in Prague .. 5
Hexagram and Hexagram in a Circle 8
Four rosettes from a Jewish sarcophagus in Shechem
 (Nablus) .. 8
Pythagorean designs from an article by Derek J.
 de Solla ... 9
Roman plate with hexagram design 14
Façade of the church of Santa Croce, Florence, Italy 15
Episcopal throne of the Cathedral of Agagni, Italy 15
Dome of the Shrine of the Immaculate Conception,
 Washington, D.C. 16
The late Friar John Marie Bursis, S.A. 17
Persian pottery from the Seljuk period 18
Yantra, a form of Mandala 18
Medieval national flags 19
Banner of Brischan (northern Africa) 20
Great Seal of the United States 21
American sheriff's badge 21
One-penny coin issued for British West Africa, 1916.... 22
Flag of the British Colony of Nigeria 22
Old Toronto City Hall 23
Illustration by Jerome Kuhl 24
"(The seal) of Joshua, son of Asaiah" 26
A shard of pottery found at Gezer 26

Hexagram carved on a stone frieze of the synagogue
 at Capernaum .. 26
Coins from the Bar Kochba revolt 27
A design from the Kennicott Bible 28
Jewish seals from the 13th and 14th centuries 31
Tombstone from 17th-century Poland 34
Torah scroll niches in a synagogue in Isfahan, Iran 35
Pentagram .. 37
Silver amulet decorated with a menorah 40
Amulet for women in childbirth, decorated with a
 Magen David ... 41
Lions of Judah decoration for mantel over an ark 41
Sabbatean Amulet 43
Kabbalistic drawing from 17th-century Italy 48
Porcelain Passover plate 51
Flag of the Jewish community which hangs in the
 Altneuschul... 52
Emblem of the Jewish Butchers' Guild 54
An artist's rendering of the Prague banner............... 55
Tombstone of David Gans 56
Tombstone of David Oppenheim............................ 56
Seal of the Jewish community of Prague 57
Compulsory headwear for medieval Jews &
 "Swedish hat" ... 58
Synagogue key from late 19th century Prague 59

Seal of Viennese Jewish community 61
Boundary marker from Vienna 62
Printer's mark from *Seder Tefillot* 66
Printer's marks used by Tobias Foà 67
Printer's mark used by Nathaniel Foà 68
Printer's mark used by Abraham ben Shabbetai
 ha-Cohen ... 69
Flag of Burundi .. 73
Dutch snuff box .. 77
Clock, Vienna, Austria 78
Diagram for Cheops Pyramid 82
Symbol of Raëliau movement 83
Franz Rosenzweig's Star of Redemption 84
Stadtkasino in Basel, Switzerland, 1897 88
Herzl's first design for the Zionist flag, 1896 89
Masthead of *Die Welt*, July 4, 1904 91
Herzl's alternate suggestion for the Zionist flag 92
Basel postmark ... 92

Flag of the B'nai Zion Educational Society 93
Official emblem of the State of Israel 95
Emblem of the Bilu Society 96
Propaganda cartoon from *Der Stürmer* 98
Heading of an editorial ''Wear the Yellow Badge
 with Pride'' ... 99
Photo of Jews wearing badges 100
Governor Wächter's edict that Jews must wear
 armbands ... 101
Badges Jews were required to wear during the Nazi
 occupation of Europe 102
Rosh Hashanah card designed by survivors of the
 Bergen-Belsen concentration camp 103
Cutting off the badge, Holland, 1944 104
Ceremonial objects made by inmates of the Terezin
 concentration camp 106
Flag of the State of Israel 107

The author gratefully acknowledges the Smithsonian Travelling Exhibition Service (SITES) and its Project Director, Anna R. Cohn, for the use of several photographs which appeared in the catalog of *The Precious Legacy: Judaic Treasures from the Czechoslovak State Collections*, co-published by Summit Books and the Smithsonian Institution.

PREFACE

It is in the nature of this book which deals with complex and often obscure historic matters that the conclusions reached can claim no more than that they are reasonable. Fortunately, I did not have to do all the research myself – far from it. Many others before me have been attracted to the puzzle which the Star of David presents: a geometric figure which in itself does not evoke any particular image and yet has become the symbol of a people who have adopted it freely and who have come to assert that these two interlaced triangles are to be considered the mark of a Jew.

Among these scholars one stands out, and I mention his contribution to the inquiry with gratitude and admiration. More than any other scholar, the late Prof. Gershom Scholem of the Hebrew University in Jerusalem has cast light into the dark corners of folklore and mysticism, and his essay on the Magen David is a true classic, to which my book owes a great deal.

Special thanks are expressed to those who helped to bring these pages to print: first and foremost Michael Neiditch, Director of the Commission on Continuing Jewish Education of B'nai B'rith International, whose encouragement was invaluable; Robert Teitler and Betty Fishman of Information Dynamics for their imagination in designing the text, and Felice Caspar of B'nai B'rith for her care in editing it.

Last but not least, I wish to thank the many friends who, learning of my interest in the subject, directed my attention to unusual occurrences of the symbol or raised challenging questions. All of them have had a share in this book.

PROLOGUE

The Search

It was 1945. Allied troops were nearing the Rhine, preparing for the final assault on Nazi Germany. The 104th Infantry Division of the American forces had entered a little city and found it in shambles. What the air attacks had missed ground artillery had finished. Only a few buildings remained standing, their roofless walls gaping blindly into the winter sky.

A church was among them, and I stopped to look at its skeleton. Its Gothic windows had been splintered; the innocent glass shattered like that of hundreds of synagogues throughout the land when, just over six years before, they had been victimized in the orgy of *Kristallnacht* (Crystal Night).

Then came the surprise. One window had remained intact. Its sole design was what Jews call the Magen David (Shield or Star of David[1]), the same hexagram which formed a prominent part of my chaplain's insignia. By common acceptance it was the recognized symbol of Judaism, and Jews were forced to wear it as a badge throughout the Nazi realm. That a window so decorated should be the lone "survivor" of the destruction seemed reassuring to a soldier returning to a land where his people had been defamed, devastated and destroyed.

Yet at the same time the sight was startling: what was a Magen David doing on a church, and a German church at that? Most certainly it was not an acknowledgment of the Jewish origins of Christianity. What then? At the time I did not know the answer; for me, the sign was thoroughly Jewish and in my experience always had been. The Magen David in that German church aroused my interest: If it was found in unfamiliar surroundings here, were there other places as well? If so, When and how did we Jews adopt it as a national insigne? I promised myself that I would attempt to explore these questions once the war was over.

And I did. I began to look for the symbol and found it in unexpected places. Its ubiquity was astounding, and I wondered why I had never noticed it before.

I examined the literature and found much of it wildly speculative – until, some time after 1948, I saw a definitive essay on the subject by the great Gershom Scholem, who

at once became my guide through the minefield of scholarly contradictions.[2]

For a number of years I collected notes and pictures, and my file grew. Then other subjects claimed my interest and for several decades the old papers dropped from sight. Almost by accident I came across them one day in 1978 and I resolved to take up the inquiry once again. It was as if I were paying a debt to my younger self. This book is the result of my old/new search.

It revealed first of all what scholars had long known: that while the sign was ancient, its connection with the Jewish people was relatively recent. In that regard – and in that regard only – it paralleled the swastika. It too was ancient and universal, and only at a late stage in history did it become associated with a particular nation.

Studying the history of the Magen David means to retrace a development which on its face is unlikely. Here is a people with a rich tradition reaching back into ancient times. They already had a recognizable symbol, the seven-branched candelabrum or menorah, yet they came to replace it over the years with another sign which evoked no immediate historical or emotional association.

In many ways that is the strangest part of the story. Symbols fulfill their function best if they are evocative. The stars and stripes speak at once of the states that form the United States; the maple leaf in the Canadian flag recalls the vast forests of the land; and Christians are reminded by the cross of the suffering and resurrection of Jesus.

But the Magen David can hardly be classed in a similar fashion. It is an abstract geometric figure which does not call to mind anything in experience or history. Yet today Jews have come to say: This belongs to me, this represents me; and therefore *today* it has assumed the status of a true symbol. But formerly this was decidedly not the case. There was a time – and not too long ago – when few Jews would have identified with the sign and when some of their leaders even considered it heathenish and totally inappropriate for use to represent the faith and people of Israel.[3]

How then did it happen that a widely scattered people, who lacked a structured religious hierarchy or secular power that could have imposed the symbol, came to accept it freely? The answer herein proposed will not move the debate beyond all dispute – there are few propositions which find universal acceptance. (Just one example: For a long time King Richard III was considered to have been a villain and murderer; there are many scholars today who believe such judgment to be a severe distortion of history.) But I will attempt to present enough facts and pictures to show *the most likely path* of this strange odyssey.

To trace the ascendancy of the Magen David involves a look at many countries in many centuries and, let it be admitted at the begin-

ning, some speculation. But then, writing history is always a process of gathering and thereafter assessing the facts.

NOTES

1 More on this name later on pp. 38 ff.
2 His essay appeared first in *Luach Haaretz* (Tel Aviv, 1948), pp. 148-163, and in English in *Commentary*, vol. VIII (1949), pp. 243-251, under the title "The Curious History of the Six-Pointed Star." Scholem later expanded the article in *Judaica* (Frankfurt, 1963), pp. 75-118 (in German). The latter was translated by Michael A. Meyer and printed in Scholem's *The Messianic Idea in Judaism* (New York, 1971).
3 On this, see below pp. 34 ff.

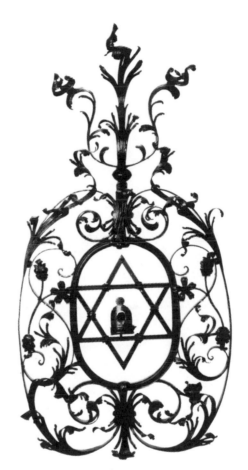

Section of grillwork from the Cikánova Synagogue in Prague, second half of the 18th century. From the *The Precious Legacy: Judaic Treasures from the Czechoslovak State Collections.* (*Photo courtesy of* SITES)

1

Form and Name

Form

The sign we now call the Magen David is a geometric figure known as a hexagram. It consists of two equilateral triangles, one placed upon (or interlaced with) the other in such a fashion that, when the six points are connected, they form a perfect hexagon: its sides too are equal and all six points are part of a circle.

In some form or other this design was found almost everywhere in the world, from ancient days on, and of course it was found among Jews as well. But while the hexagram was used quite often it cannot be said that it was a great favorite with the potters and stone masons whose work has survived from antiquity.

To be sure, they *did* use it, but rarely in its pure form. More frequently they drew the so-called "rosette," a round, sun-like design which appeared in the ancient Near East in great profusion and in many variations. Among these, the six-pointed or "compass rosette" was the most common, so that it has been referred to as the "banal" rosette.

It has been found as early as the third millennium before the common era, in Mesopotamia as well as in ancient Egypt and pre-Israelite Palestine. Later on, we find it in Cyprus, Greece and especially often in Persia, where Jewish craftsmen may have encountered it during the days of their exile in the

sixth century B.C.E. From then on the "banal rosette" makes frequent appearances in many places, and when Greek and Roman culture became dominant we find the figure was often used on friezes and sarcophagi, of non-Jews as well as Jews.

The greatest student of this subject was Professor Erwin H. Goodenough who published a huge collection of rosettes of all kinds.[1] Their round shapes evoked the image of the sun and therefore a sense of awe, and thus were believed to have protective power.[2] He suggested that the pure geometric hexagram had its origin in the "banal" rosette, and that like its model it originally had no particu-

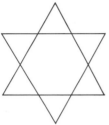

Hexagram and Hexagram in a Circle

Four rosettes from the face of a Jewish sarcophagus in Shechem (Nablus). The floral rosette on the right is six-leafed, the two center designs are "geometric rosettes" and double-six-leafed. The "banal" rosette arose from such designs. Pictured in Goodenough, *Jewish Symbols in the Greco-Roman Period*, vol. 7, p. 179. (*Photo courtesy of the Library of Congress*)

lar Jewish meaning. In that regard it was much like the pentagram, the five-pointed star, which also enjoyed great popularity among the ancients.

Why did they use the hexagram so often?

One reason no doubt was its pleasing, "perfect" shape which appealed to the artist as well as the mystic. A mystique adheres to the perfect form, such as the circle and the equilateral triangle, and the hexagram combines them. A second reason, Goodenough believed, was that "the rosette had become a free symbol, applied to any deity. It is the most likely hypothesis that for the Jews too the rosette had come to symbolize their God and their hope and had come to do so because, it is certain, they had learned to think of the Deity as the unit embracing all complexity and the center from which all life radiates."[3] Accordingly, it was more than mere decoration.

A further reason for its popularity lay in the various other mean-

ings ascribed to the sign. For instance, in some places a hexagram was placed on sarcophagi and other funerary objects because it was believed to protect the dead, while in ancient Tyre, along the eastern shore of the Mediterranean Sea, people would place the figure on a signet ring and call it a "ring of hospitality." Two friends who wanted to pledge each other unending faithfulness broke the ring in half and each kept one half as a reminder of their bond.

The hexagram and the pentagram were also believed to reflect the basic elements of existence and combine them in various ways. Thus, fire and water, air and earth, wet and dry, hot and cold, positive and negative figured in symbolic combinations which then assumed the function of talismans.[4] In antiquity such figures were true symbols in the sense that they spoke to people without the intervention of words.[5]

In Egypt, the two triangles were usually *not* linked, but separately

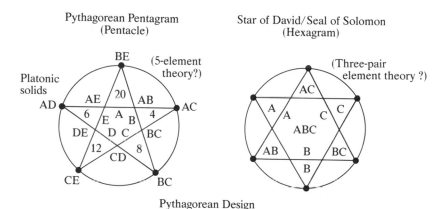

Pythagorean Pentagram
(Pentacle)

Star of David/Seal of Solomon
(Hexagram)

Pythagorean Design

Derek J. de Solla Price likens the hexagram to the Boolean principle in formal logic. Pythagorean designs are from his article on scientific talismans and symbols in McTeich and Young, *Changing Perspectives in the History of Science* (London, 1973), p. 261.

they had distinct symbolic meanings. The delta with its point upward △ represented fire and/or an angry god; with its point downward ▽ it meant water and/or a gracious god. But some scholars believe that when the triangles were linked in the form of a hexagram, as they were occasionally, they assumed cosmic significance, and this symbolism was said to have been incorporated in the great Cheops pyramid.[6]

In sum, the form was ubiquitous (as shall be shown further on), and its meaning among Jews a composite: it spoke of God, of hope, and of divine protection.

Name

The hexagram is commonly known today as the Shield or Star of David, or in its Hebrew form, *Magen David.*

Magen is a word which occurs frequently in the Bible. Its basic meaning is "shield" – a piece of defensive armor, carried in battle. But the word was also used figuratively for the Almighty as the protector or shield, a *"Magen* to all who trust in God."[7] Particularly, God is described as the *Magen* of Abraham,[8] and the first of the eighteen benedictions which form the core of the daily Jewish service ends with the phrase, "Blessed are You, Lord, *Magen* of Abraham." Similarly, one of the benedictions which follows the synagogue reading of the prophetic portion of the Bible (Haftarah) ends with "Blessed are You, Lord, *Magen David.*"

This old figurative expression (which clearly was not restricted to David) reinforced the legend that the hexagram which now goes by that name was in some fashion associated with King David, who ruled Israel one millennium before the common era. There is however no evidence to this effect, and in centuries past the symbol was in fact more frequently associated with King Solomon who was supposed to have used it for magic purposes on his signet ring. Consequently it was often known as Seal of Solomon, *Ḥotam Shelomo,* but the connection with Solomon has as little support in history as its link with David.[9]

It is important therefore to distinguish between two separate questions before us:

First, how did the hexagram, a universal "free" symbol, become identified with the Jewish people, and second, how did it obtain its name? (Therefore, in the pages that follow, use of the term "Magen David" does not necessarily mean that the symbol already bore that name at the time which is under discussion. That identification arose quite slowly.)

NOTES

1 *Jewish Symbols in the Greco-Roman Period* (New York: Pantheon Books, Bollingen Series XXXVII), from 1953 on, vol. 7, pp. 179 ff. (Goodenough calls this volume *Pagan Symbols in Judaism*). See also vol. 3, illustrations 251, 358, 474, 616.

2 Similarly, the crescent evoked the moon and was often shown along with rosettes. See pictures in Goodenough, vol. 7, p. 181.

3 Vol. 7, p. 197.

4 See Derek J. de Solla Price, "The ✡ ☆ and ⬡ and other Geometric and Scientific Talismans and Symbolisms," in McTeich and R. Young, *Changing Perspectives in the History of Science* (London: Heinemann, 1973), pp. 250-264.

5 Price, *op cit*, p. 261. Price likens the hexagram to the Boolean principle in formal logic.

6 See below, p. 81.

7 II Sam. 22:31.

8 Gen. 15:1. God as *Magen* is a metaphor often found in Psalms and Proverbs. Sometimes the leaders of the country too are described as its "shields" (Psalm 47:10).

9 See further below, pp. 37 ff.

2

A Universal Sign

A complete catalogue of the hexagram's occurrences is impossible to fashion. As has already been indicated, it is found everywhere and in all ages, and one must therefore resist the temptation to find in all of them the "Jewish connection." But at some time in history this connection did emerge, and consequently all reports and interpretations should be approached with due attention.

At the end of the Second World War, a physician who was greatly interested in the origins of the hexagram made a special journey to the Syrian city of Baalbeck, near Damascus, site of important excavations. Dr. Leon Kolb had heard that hexagrams could be seen among the uncovered ruins. After he returned to the United States he reported on his findings:

> There was a temple district of about 100 B.C.E. of mixed Semitic and Roman character. The buildings even were set in a hexagon.... The ceiling of the best preserved building, the Bacchus Temple, was covered with Magen Davids.[1]

An archeologist suggested the reason: the Semites who inhabited the area were worshippers of sun, moon and stars and were students of astronomy and astrology. The hexagram provided them with an astronomical division of the sky circle and thereby achieved a kind of "emblematic" status.

Perhaps. Such speculation is as problematic as it is emblematic. It may have been purely decorative and it may have been more. We shall encounter this uncertainty time and time again as we meet the hexagram in unexpected places.

Dr. Kolb had earlier come across the hexagram in 1914, in a little village in Austria where no Jew had resided within memory. Babies' cradles were liberally decorated with the symbol and so was an occa-

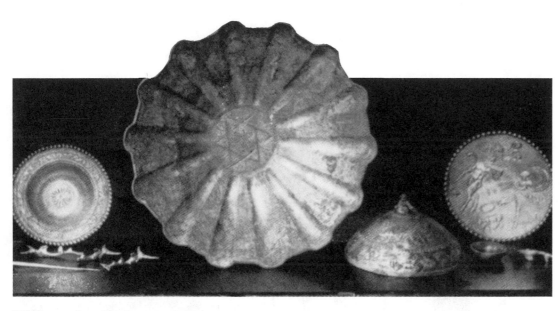

This Roman plate with a hexagram design was unearthed by a farmer in Mildenhall, England. Photo by F.E. Williams appeared in *The Roman Way* by Edith Hamilton, which was reprinted in *National Geographic*, Nov. 1946, p. 565. (*Photo courtesy of the Library of Congress*)

sional door post. The local tradition was that hexagrams drove away evil spirits (a tradition that existed even more strongly for the pentagram). Why? And where did this belief originate?

Dr. Kolb was told that this had something to do with the Turkish siege of Vienna back in the sixteenth century. It was said the Turks carried the hexagram on their battle flags (for which there is no proof, but that does not matter much when it comes to folk beliefs), and since the Austrians considered the Muslim Turks (like the Jews) as devils, they warded them off with their own heraldic design.[2] Such procedure might not meet the laws of logic, but it does make "sense" in magic where everything is possible. After all, didn't the Turks break off the siege, never to return? If the good Viennese defenders did use the hexagram to halt their enemies, their tactic was evidently successful, something which, as in all matters of superstition, is rather difficult to disprove.

That is, if one wants to believe the tale and not simply surmise that the local carpenter either practiced magic or just liked the design and put it on cradles he fashioned, and that others imitated him. For it was a local custom only, not found in other towns or villages. The Turkish connection had more glamour, so why look for another explanation? We often meet such speculation when we consider matters of this sort, and we have to guard against it.

Wherever one looks, at almost any time in history, the design appears. Thus it is found on a decorated silver plate the Romans brought to England when they occupied the island between the first and fourth centuries.

The hexagram can also be found in a number of Christian shrines. For instance, one may see it on a bishop's throne in Anagni (Italy), on the ceiling of a church in Aquileia (northwest of Trieste), on the public square in front of the cathedral in Orvieto (in central

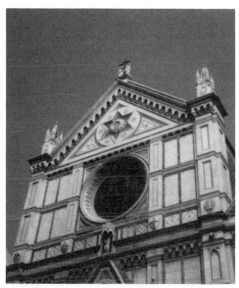

The façade of the church of Santa Croce in Florence, Italy, is decorated with a hexagram. This church contains the crypts of many prominent historical figures, including Michelangelo and Galileo. (*Photo by R. Teitler*)

The episcopal throne of the Cathedral of Anagni, Italy, features a hexagram carved into the marble slab above the headrest; it dates from the 12th or 13th century. From E. Hutton, *The Cosmati* (London, 1950), pictured in *Encyclopaedia Judaica*, vol. 11, col. 690. (*Photo courtesy of the Library of Congress*)

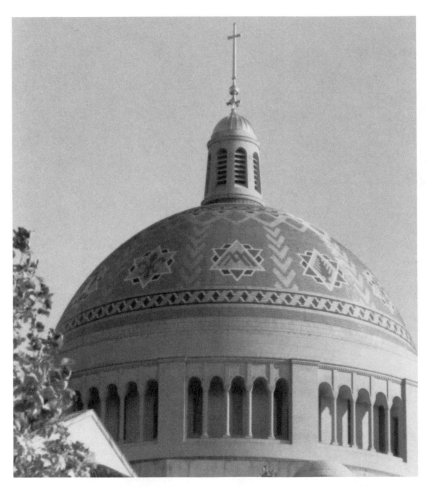

The dome of the Shrine of the Immaculate Conception, built 1920-26 at The Catholic University of America in Washington, D.C., is decorated with designs shaped like hexagrams. (*Photo by C. Fishman*)

Italy), on the dome of the National Shrine of the Immaculate Conception at the Catholic University of America in Washington, D.C., and on the floor of the Ecce Homo basilica in Jerusalem. One Roman Catholic order had a large hexagram emblazoned on the habit of its members. It is now worn as a pendant together with a cross.

In the Philippines, many Christians wear it as a pendant with the figure of the Santo Niño (the "Holy Child") in its center.

Egyptian Copts used it on amulets together with a cross (which reminds one of the practice of many Christian soldiers in the American army in World War II who fortified themselves by wearing both Jewish and Christian symbols). Among the early aficionados of the hexagram were also Germans who decorated coins and churches with the emblem. They continued to do so into the nineteenth century, when churches in such cities as Stendal, Brandenburg, Lüneburg and Hanover, as well as the church

mentioned in the Prologue, were embellished with it.

Scholars note that it has been found in Sudanese as well as Mesopotamian antiquities; and not surprisingly it was used widely in the Islamic realm. There, the decorative arts reached their peak, and it was a foregone conclusion that one would frequently come upon the hexagram on mosques and other public buildings, on doors and tombstones, as well as on private utensils and in manuscripts. Thus, a handsome luster plate from Persia, fashioned in the thirteenth or fourteenth century, may be seen in the Freer Gallery of Art in Washington, D.C.

In India, too, where Islam became ensconced from the sixteenth to the eighteenth centurics through the Mughal dynasty, the hexagram appears as a building decoration, and in the non-Muslim environment it is part of the "Yantra" design.

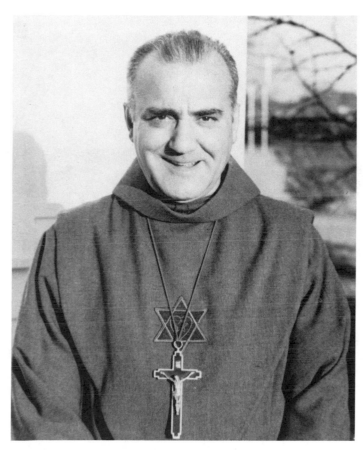

The late Fr. John Marie Bursis, S.A.
For centuries the Magen David was part of the emblem of the Order of Franciscan Friars of the Atonement and stood for "faith." (The six-pointed star represented "hope" and the heart "charity.") (*Photo courtesy of the Ecumenical and Interreligious Commission of the Archdiocese of New York*)

Persian pottery from the Seljuk period, early 13th century, in the form of a six-pointed star. (*Photo courtesy of the Freer Gallery of Art, Smithsonian Institution, Washington, D.C. Acc. no. 03.197*)

In Ise, Japan, the hexagram may be seen many times on a long row of columns.

Among the most fascinating occurrences are the flags which were in use during medieval times – or at least were reported to have been in use – in Europe, North Africa and Asia Minor.

Yantra, a form of Mandala Pictured in Jung, *Der Mensch und seine Symbole* (London, 1964), p. 240. (*Photo courtesy of the Library of Congress*)

During the fourteenth century, an unidentified Franciscan friar created a map which among other things purported to show a number of flags in their full colors.[3] There, the flag of Lithuania (called "Litefania" by the author) is depicted as white with a blue hexagram (blue and white!), and that of neighboring Poland as green, red and white, embellished with the same symbol. If in fact such were the national colors, they could hardly be traced to Jews, whose numbers in these countries were still small at that time.

The Lithuanian and Polish banners were not the only ones shown by our friar to have had a six-cornered design. He depicts two flags for Satalia in the province of Naturi, which corresponds to Anatolia in Asia Minor. (This Satalia is the same as today's Adala in western Turkey (east of Izmir), an identification which we can make from another map that appeared in 1375.[4]) One flag contains a black hexagram superimposed on a white

Litefania

Poland

Satalia

Satalia

Medieval national flags as depicted on plates 3, 9, 13 in Markham, *Libro del Conoscimiento* (London, 1912).

Brischan

Based on Markham, *Libro del Conoscimiento* (London, 1912).

background with wavy grey stripes, and another red-bordered banner has the emblem located above the stripes.

Our friar-cartographer also reports that a banner flown over a city called Brischan, in northern Africa,[5] showed a black hexagram with two small circles embellishing each of the six points, on a plain white background.

How reliable are these reports? Some may be accurate, and some purely imaginary. Certainly in Schedel's famous world history (published in 1493, among the earliest printed books) all illustrations are fanciful, to the extent that even ancient Babylon in the sixth century B.C.E. is naively shown with churches topped by crosses! And one should note that the German cosmographer and Hebrew scholar Sebastian Münster, who published his *Cosmographia Universalis* in 1544, assigns quite different insignia to Lithuania. But then again these may have been changed during the two hundred years since the

Franciscan friar produced his world map.

An even earlier depiction of contemporary flags comes to us from the year 1360, fifteen years before the friar's creation. It too shows hexagrams for various locales in North Africa and Asia Minor – for such places as Tarsus, Aldano and Manustra (in Armenia).[6] Unfortunately none corresponds to the friar's map, which leads one to believe that the imagination of the draftsmen supplemented what accurate reportage could not supply.

But one conclusion may be drawn even from these dubious sources: quite obviously, those who created the images did not think of the hexagram as a Jewish symbol. (Whether that held true also for another famous map of the fourteenth century, one that was drawn by a *Jewish* cartographer called Cresquez, is another question to which we shall turn in the next chapter.)

In sum, the hexagram as a geometric design, as a perfect shape, as

a religious sign, or as a magic symbol could be found from ancient to modern times, and in many climes and continents – without having a specific Jewish association. This becomes abundantly clear also if one stays close to home and looks at the North American scene.

The United States Congress, after discussing for six years the subject of a Great Seal for the United States, finally (in 1782) agreed on a design. It may most conveniently be seen on the ordinary dollar bill: on the obverse an eagle holds an olive branch in one talon and a sheaf of arrows in the other. Above it shines a radiant group of 13 stars (one each for the founding states) which are arranged in the form of a hexagram. Why this shape? What was its symbolism, if any?

The familiar design was suggested by Secretary of the Treasury Charles Thomson, but no reasons were given why this and none other was chosen. Was it Masonic imagery? Quite possibly, for such influence is suggested by the design

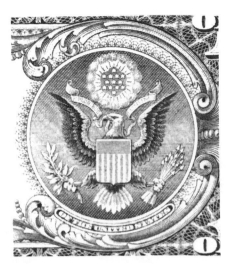

The Great Seal of the United States as it appears on the back of the one-dollar bill. Notice the 13 stars in the form of a hexagram above the head of the eagle.

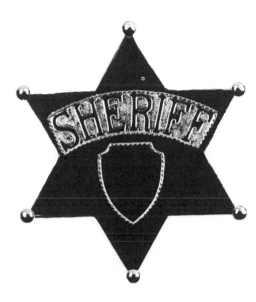

American sheriff's badge.

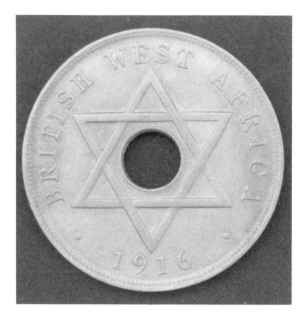

The Magen David on the one-penny coin issued
for British West Africa in 1916 (dia. 1.25″).
From the collection of Dr. Fred Weinberg,
Toronto. (*Photo by David Latchman*)

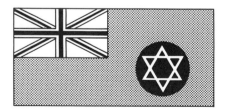

Flag of the British colony of Nigeria.

on the reverse, with its uncompleted pyramid and divine eye. Or did the thirteen stars simply lend themselves well to being shaped into a hexagram? Nothing in what the Secretary of the Treasury or Congress pronounced on the subject suggests any relation to the Jewish people.

Nor did the police and sheriffs' badges in the United States have a Jewish origin. Perhaps these badges were fashioned after the Great Seal – in any case, no wearer of the emblem has concluded that because of the badge's six-pointed star he or she derived enforcement powers from the Jews.

In 1916, the British administration of what was then called West Africa created a one-penny coin which featured a six-pointed star, and also placed the symbol on the flag of Nigeria, its colony and protectorate.[7]

Canada, too, presents its contribution to the hexagram's ubiquity. A hexagram appears on stained-glass windows in the (Anglican)

Church of the Redeemer in Toronto, and in the foyer of the library of Osgoode Hall.[8]

As late as 1899, when Toronto built its new city hall, architect E.J. Lennox decorated the facade with a large hexagram, along with other figures.

The city fathers might have disapproved of its use in the town hall had they realized that a year earlier, in far-off Switzerland, the new Zionist movement had displayed it on its flag and thereby made it its symbol. Toronto's politicians *might* have looked for a different decoration, and then again they might not. For, Zionism notwithstanding, the sign was still not *the* generally recognized Jewish symbol, and even much later did the city's prime establishment church, Timothy Eaton Memorial, display the emblem on a pulpit altar cloth. Its use evidently did not evoke the image of a Jewish connection.

It was – and in this respect remains – simply a six-pointed star. Contrary to some beliefs, the whole

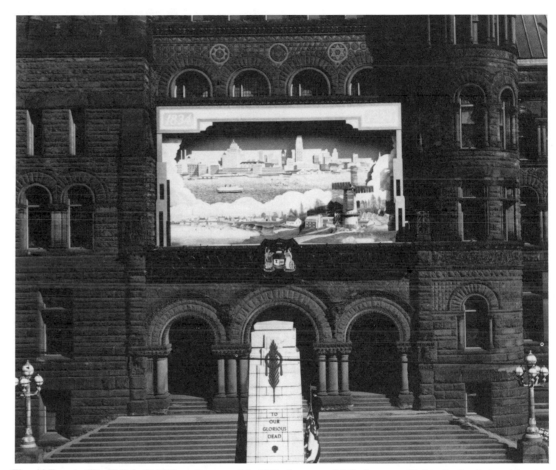

The old Toronto City Hall, built 1899, as it appeared in 1934 when a special display was added to the facade in celebration of the city's centennial. The Magen David design appears as the right-most of the three emblems over the windows just above the centennial display. (*Photo courtesy of the City of Toronto Archives*)

TWO SUBJECTIVE TRIANGLES, one whiter than white and the other blacker than black, appear to have distinct contours, but when the contours are examined closely, they disappear. The contours are subjective and have no physical reality. The region bounded by the subjective contours appears to be more intense than the background even though the color of the inner and the outer regions is identical.

Illustration by Jerome Kuhl in "Subjective Contours" by Gaetano Kanizsa, from *The Mind's Eye, Readings from Scientific American* (1986), p. 82. (*Photo courtesy of the Library of Congress*)

world is neither Jewish nor under the sway of the mystical Elders of Zion. Which is another way of saying that for most of human history the hexagram had no specific Jewish connotation whatsoever.

Even today the hexagram is frequently used in scientific studies (with no religious association intended or apparently perceived) to demonstrate varieties of visual impressions.

NOTES

1 *Jewish Herald*, April 12, 1946.
2 *Ibid.*
3 *Libro del Conoscimiento, etc.*, ed. by Sir Clements Markham (London: Hakluyt Society, 1912), plates 3, 9, 13; see also there, pp. 19 and 125.
4 Reprinted in Walter W. Jervis, *The World in Maps* (London, 1936).
5 Probably today's Biskra which, however, lies inland, south of Bejaia.
6 Lee Wheeler-Holohan, *Flags of the World* (London-New York, 1939).
7 The design was changed when Nigeria obtained its independence in 1960.
8 According to Ken Jarvis of the Law Society of Upper Canada, it was referred to as the Seal of Solomon and was to symbolize the King's legal wisdom.

3

Early Appearances in the Jewish Realm

It is always hazardous to affix the label "earliest" to a historical phenomenon, for most likely earlier examples will come to light in due course. So we will be cautious and state that two appearances of the hexagram in the seventh century B.C.E. are the first so far discovered in a distinctively Jewish setting. The emblem is displayed at the end of Hebrew inscriptions, as a sort of final signum.[1]

However, we know of older occurrences in Palestine, albeit not in a Jewish context. Pottery shards from the sixteenth to thirteenth centuries B.C.E., well before the conquest of the land by the Israelites, have been found at Gezer. Therefore, when Joshua and his people entered the land the hexagram was already in use by its inhabitants.[2]

A stone excavated at Megiddo also bears the sign, but since it lacks a particular context its exact age is uncertain. It is well to remember that the hexagram appeared from the Bronze age on throughout the Near East and beyond, "possibly as an ornament and possibly as a magical sign."[3]

A thousand years later not much had changed in this regard. This is amply borne out when one studies Goodenough's monumental work on Jewish symbols in the Greco-Roman period, which encompasses a few hundred years before and after the common era.[4] Goodenough cites and pictures a variety of the sign's occurrences in Palestine, in different ages. We see it portrayed in Jerash on a lamp, in Kfar Yosef and Beth Shearim on tombs and a cemetery wall, probably as a protective symbol.[5]

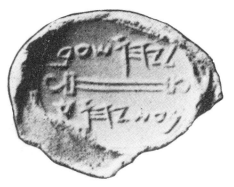

"(The seal) of Joshua, son of Asaiah"
From Torrey, *Journal of the American Oriental Society* (1903), P. 204. (*Photo courtesy of the Library of Congress*)

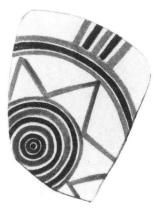

A shard of pottery, broken but with enough remaining intact to show that the design was a Magen David. Macalister, *The Excavation of Gezer* (London, 1912), vol. III, Plate CLIX, no. 12. (*Photo courtesy of the Library of Congress*)

Hexagram carved on a stone frieze of the synagogue at Capernaum, dating from the second century C.E. Photo by Werner Braun, Jerusalem, as pictured in *Encyclopaedia Judaica*, vol. 11, col. 689. (*Photo courtesy of the Library of Congress*)

One oft-cited example of early Jewish usage is a frieze in Kfar Nachum (Capernaum) which was probably fashioned a century or two before the common era. But since the sign appears together with other designs it is clear that its employment here had no special significance.[6]

A claim for a distinctively Jewish connotation can possibly be made for a coin struck by Simon Bar Kochba, in the year 135 C.E., during the Jewish war against the Romans. Such a coin became the object of much public discussion when it was discovered in a most unlikely place: in a pig pen in Clay City, Powell County, Kentucky. (Some people speculated at once that, if the coin was genuine, here was proof positive that the ancient Judeans had travelled to America, a claim which we shall not examine here.) How the coin got to Kentucky is less important for our inquiry than the knowledge that the picture of such a coin had already been published some forty years

before, and that it was not unique.[7]

The coin is dated "Year 2 of the Freedom of Israel" and shows on one side a Temple-like structure with a figure resembling a hexagram crowning it. The figure quite clearly functions here primarily as a star and as a sign for Bar Kochba, the leader of the war of liberation. For his name was taken to mean "Son of a Star" and to evoke the biblical prophecy that "a star will arise from Jacob."[8]

Indeed, had the revolt succeeded, such a star might even have taken its place among the important Jewish images. But with the defeat and devastation that befell the people this did not happen. Still, one cannot rule out that a star-shaped symbol – possibly seen as a hexagram – was here given a redemptive, quasi-messianic significance which may have left its traces in the subconscious of the Children of Israel.

But we should not exaggerate the importance of the Bar Kochba coin. The Goodenough studies make it clear that at that time the hexa-gram was just one of many designs in use in the Jewish realm and, counting the occurrences recorded by the author, not a very prominent one.

A noteworthy depiction of the hexagram in a Jewish context was discovered on a tombstone in south-eastern Italy, in Taranto (then called Tarentum).[9] The stone dates from the sixth century or even earlier and reads as follows:

פה ינוח אשת	Here rests the wife of
✡ לאון בן ✡	Leon, son of ✡
דויד מן	David, from
מילו	Milo.

One might suppose that here indeed is an instance not only of the hexagram in a Jewish setting, but also of linking the sign with the name of David, an early attestation of the hexagram as a Jewish symbol with the name we know today. Yet this occurrence is so isolated that we cannot securely draw such a conclusion. A more conservative judgment is indicated: the sign was personal and probably used as a

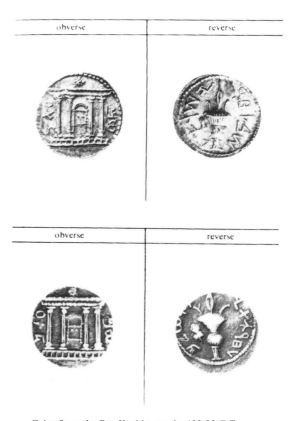

Coins from the Bar Kochba revolt, 132-35 C.E. On each, the obverse view shows the Temple at Jerusaelem with a rosette (hexagram) above the lintel. Pictured in *Encyclopaedia Judaica*, vol. 5, col. 709-10. (*Photo courtesy of the Library of Congress*)

A design suggesting the Magen David. From the Kennicott Bible (15th century, Spain), pictured in *Sefarad* 12 (1952), p. 356 plate II. (*Photo courtesy of the Library of Congress*)

magic protection for the dead. It is possible that King David's power was meant to be invoked to assure this protection.[10]

As time goes on, the Magen David is found more often. But that may not necessarily be due to the ascendency of the sign among the Jews, but rather to the growing survival rate of manuscripts and other objects. Thus, in the ninth and tenth centuries we begin to find the hexagram more frequently on tombstones and in manuscripts. For instance, a manuscript dated 951 and preserved in the Leningrad Library shows the hexagram along with octagons and figures closely resembling swastikas.[11] But on the whole the increase in the number of hexagrams found in the Jewish realm is so modest that it may be said with certainty that at the time of Rashi (tenth century) the sign was not considered a specifically Jewish symbol.

However, manuscripts were now more elaborately decorated, as the art of calligraphy was making

strides among Jews as well. Title pages especially were arranged artistically and occasionally showed the Magen David among other decorations.[12] But it is difficult to say how much these displays were pure artistry and how much was belief in the magical efficacy of certain signs and symbols.

The art of calligraphy reached its apex in the world of Islam and here too the hexagram is found in all manner of manuscripts, and appears overwhelmingly, it would seem, as an artistic design. In Christian calligraphy, however, the sign is all but absent, but not because it had already assumed a specific Jewish identity. Christian calligraphy, especially in sacred texts, was amply overshadowed by pictorial representations which thereby assigned to calligraphic decorations a level of lesser importance.

We are now entering a time when mysticism became an important aspect of Jewish life. From mystical speculation to magical practice (called *kabbalah ma'assit*) was often

only a short step; the universe, it was believed, was accessible to human mastery if one but had the proper key, the proper formula, the proper sign, and above all, if one knew the secret name of God. Inscribing it on a clump of clay could bring an inanimate form to life – a feat later ascribed to have been accomplished by the High Rabbi of Prague who fashioned the legendary Golem. Current among the people were the stories of King Solomon who commanded the world of spirits and demons by dint of his magic ring which was said to have been inscribed with the hexagram (which was therefore often called Seal of Solomon[13]).

The Karaite scholar Judah Hadassi, who lived in Constantinople in the twelfth century, wrote a famous book, one passage of which has served as the proof text that in his day the hexagram was already established as a Jewish symbol. Judah was a great believer in secret devices and quoted particular inscriptions as effective tools. The

passage alluded to reads (in translation) as follows:

> Seven names of angels are written before [the text of] the mezuzah: [here follow the names]. May the Lord protect you! And this symbol [called Magen David] is written beside the name of each angel.[14]

It will be noted that the nineteenth-century printer left an empty space for the symbol where seven hundred years before Hadassi must have written it into his manuscript. The manuscript at the printer's disposal evidently also left the space empty, either as an oversight or because the text from which he copied did not show the sign Hadassi had intended.

Furthermore, one should note that the words "called Magen David" are encased in brackets, which may not have been Hadassi's own explanation but that of his chief annotator, Caleb Afendopolo, who lived several hundred years

later than Hadassi. Not until all of the latter's extant manuscripts are examined in this respect will we be able to determine whether he was indeed the first writer so far discovered who linked the hexagram to the name Magen David.[15]

An equally intriguing though usually overlooked source is the cartographer Cresquez lo Juheu (the Jew) who was charting the waves from his home on the island of Majorca, in the western Mediterranean. There he belonged to a group of map makers, some of whom were Jewish, who supplied the seafaring trades with charts, commonly called *portulani*. Cresquez produced his best-known effort in 1375 and he dots his map with many flags to show kingdoms and other fiefdoms.[16]

Now 1375 was also the year when our aforementioned unknown friar provided us with many colorful images of flags and emblems.[17] Do his pictures correspond to those of Cresquez?

In some ways they appear to do just that. Cresquez, as far as one can see from the reproduction, gives us three locations where the hexagram was used on banners, and two of them – one in Morocco and one in Turkey – correspond broadly to the friar's depiction of Brischan and Satalia. (The third flag is affixed to southern Turkey.) In all these instances the hexagram is clearly delineated, in contrast to his other flags whose designs (at least in the reproduction available) are quite indistinct and undifferentiated. One might therefore be led to the conclusion that perhaps Cresquez showed the three flags so clearly because, as a Jew, he wanted to make a statement, and that in his time the Magen David was already an identifiable Jewish symbol. But since one researcher wrote that she had found the symbol on other *portulani* as well,[18] the argument fades away. Which leaves us about where we were.

What about the confluence of the Brischan and Satalia designs in the friar's and Cresquez's maps? Did one copy from the other? Is it a coincidence? Or did these cities indeed feature the Magen David as their ensign? This is possible, and perhaps even likely. It would underscore the fact that in the fourteenth century the design was still a "free symbol" as it was in ancient days. Jews used it and used it often, and its major function was to protect places and persons – a usage paralleled amongst other nations and cultures. At times, secret powers were believed to adhere to the particular geometric design and sometimes to the fact that star-shaped objects were widely seen as heavenly protectors.[19] Jews would sometimes connect such charms with the legends of Solomon and the power of David, or use them without such ascriptions. Which is to say that the hexagram, which is the focus of our inquiry, was well known to Jews but had in no way become for them, or for anyone else, a specifically Jewish sign.

NOTES

1 See Charles C. Torrey, *Journal of the American Oriental Society* (1903), p. 204; Gershom Scholem, *Encyclopaedia Judaica*, vol. 11, col. 687.

2 Stewart Macalister, *The Excavation of Gezer* (London, 1912), vol. III, Plate 159, no. 12. It should be noted that one scholar (Duncan, *Corpus of Palestinian Pottery* (London, 1930), pp. 7 and 10) dates the material to 1300 B.C.E., near the time of Israel's exodus from Egypt and subsequent entrance into Palestine.

3 Gershom Scholem, *loc. cit.*

4 See above, p. 11 note 1.

5 A replica of the latter, with the Magen David highlighted, may be seen in the Maritime Museum in Haifa.

6 The same may be said of other finds, some of which may come from earlier times. See David Diringer, *Le Iscrizione antico-ebraiche Palestinesi* (Florence, 1934), pp. 130-132.

7 See Edgar Rogers, *Handy Guide to Jewish Coins* (London, 1914).

8 Num. 24:17; the Hebrew word for star is *kochav*.

9 H.M. Adler, "The Jews in Southern Italy," *Jewish Quarterly Review*, XIV (1902), p. 111. Adler suggests that "Milo" in the inscription refers to the island of Melos.

 Of a similar genre is the copy of a

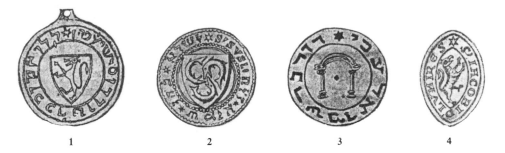

Early occurrences of the Magen David on Jewish seals, from the 13th and 14th centuries, as pictured in the *Jewish Encyclopedia*, vol. XI, plate II, following p. 136.

 1. From Germany or France
 2. From Switzerland
 3. From Baghdad (?)
 4. From England

contract dated 1062 and found in The Central Archives for the History of the Jewish People in Jerusalem. At the end of the document is the Hebrew signature of one of the contracting parties, Vidal Shelomo (Solomon) of Barcelona, and immediately following it a hexagram with a dot in the center. In this case apparently, the symbol was considered the "Seal of Solomon" - if indeed it was not added later.

10 One may note incidentally that the Hebrew grammar of the sign is faulty. The word יגוח should read תגוח, and the use of the future tense may also be said to be unusual.

11 See Ernst Cohn-Wiener, *Die jüdische Kunst* (Berlin, 1929), p. 148: T. Nussenblatt, *Yivo Bleter* (Sept.-Oct. 13, 1938), nos. 5-6, p. 466: D. Günzburg and W. Stassof, *L'ornement hébraïque* (Berlin, 1905), plate 8.

12 Specimens from Paris and Oxford have been reproduced by Cecil Roth, *Sefarad* 12 (1952), p. 356 plate II; also by Cohn-Wiener, cited above.

13 More on this below, pp. 37 ff.

14 *Eshkol ha-kofer*, Eupatoria (Goslow, 1836); reprinted in Westmead (England, 1971), #342. The Karaites ("scripturalists") rejected the authority of the Talmud and claimed sole authority for their biblical interpretation.

15 Eliezer ben Yehudah, in his pathbreaking *Dictionary and Thesaurus of the Hebrew Language*, reprinted by Thomas Yoseloff (New York-London, 1960), vol. 4, p. 2787 (footnote), derived from the number of angels (seven) the conclusion that the empty space was meant to contain the hexagram. It is not clear how he arrived at this highly speculative conclusion. (Also, Scholem, *Messianic Idea*, p. 267, clearly erred when he wrote that the printer had added the hexagram.)

In the same vein one meets the assertion that the great mystic Isaac Luria (called the Ari), who lived in Palestine in the sixteenth century, had written of the Magen David as a Jewish symbol, and later writers repeated this assertion. However, Scholem (p. 261 f.) maintains that nowhere in Luria's writings can such a passage be found.

16 The original is in the Louvre. A copy of a copy may be seen in the *Jewish Encyclopedia* (New York, 1904), vol. III, p. 678 (insert).

17 See above, p. 19.

18 Rachel Wischnitzer-Bernstein, *Symbole und Gestalten der jüdischen Kunst* (Berlin, 1935), pp. 75 ff.

19 See the detailed analysis of this aspect by Goodenough, vol. 7, pp. 188-201.

4

Absence and Opposition

We will pause for a moment and assemble what may be called "negative evidence" which shows that the hexagram did not function as a "Jewish" symbol, either in early days or in medieval times, and we will take this negative evidence up to modern days. In our context, negative evidence may be seen to exist when in a distinctively Jewish setting one could expect the depiction of the Magen David if it was indeed at that time identified with the Jewish faith and people. Only a few examples need be given.

A gold glass from fourth-century Rome (on exhibit at the Israel Museum in Jerusalem) shows two candelabra with ritual items and two lions guarding an ark, but no hexagram.

A tenth-century picture of the tablets of the Covenant shows a plenitude of designs — circles, rhomboids, rectangles — but no hexagram. There are triangles to be seen, but they are placed one above the other, and none is inverted.[1]

The well-known Hereford atlas, which stems from the twelfth century, features many symbols. But when it comes to Jerusalem — depicted as the center of the world — it shows no Magen David for the Eternal City.

A Persian synagogue of 1550 had elaborate decorations, but still no Magen David.[2]

In seventeenth-century Poland, a tombstone features a design which in its very resemblance to the Magen David is clearly oblivious of it.[3]

A century later, in Italy, we find *ketubot* (marriage contracts) displaying all manners of decorative designs, such as the menorah, hands raised in blessing, or crowns — but no Magen David.

As we shall see further on, the nineteenth century saw an enormous proliferation of the symbol, but at the same time it also saw vigorous opposition to its increased

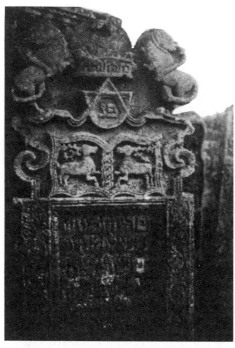

Tombstone from 17th-century Poland with a design
resembling the Magen David, from Loukomski,
Jewish Art in European Synagogues (London,
1947), p. 180. (*Photo courtesy of the Library of
Congress*)

usage. None other than the widely
read poet and journalist Judah Leib
Gordon strongly protested when in
1879 the new synagogue in St.
Petersburg (now Leningrad) was to
be decorated with the Magen
David. He called it a heathenish
symbol and traced its use to
"Magen Druid" – derived from the
Druids who were members of a reli-
gious order among the Celts, before
the advent of Christianity.[4]

The century's greatest authority
in the field tended to agree with the
negative judgment on the Magen
David. Leopold Löw was a Hungar-
ian rabbi who wrote the classic
work on Jewish graphic creations.
He called the Magen David
un-Jewish and derived from Ger-
man mythology, and added: "In
many places one can see the Magen
David *even now* [emphasis added]
with women who have given birth,
and the sign is also displayed on
communal seals and synagogal
ornaments."[5] And a German
preacher of the time asked plain-
tively: "Why do people put a

Magen David on synagogues?"[6]

Even in 1904, when the *Jewish
Encyclopedia* – the first great com-
pendium of Jewish knowledge –
was compiled, the article on the
Magen David was quite brief.[7]
While it described the by-then fre-
quent use of the symbol, it was in
no way identified as "the" Jewish
sign. Quite clearly, it had not as yet
achieved its representative
character.

Two more examples will suffice
to show that as late as the time of
the First World War (1914-18) the
Magen David had not yet been
accepted by all Jews as their
symbol.

During the war, Americans as
well as Germans buried their Jew-
ish dead under the sign of the
Magen David. The French War
Department also considered the
matter and in two orders in 1917
directed that "a form of the special
emblem called Magen David" be
used for this purpose.[8] However,
the French Jewish ecclesiastical
authority (the *Consistoire*) objected

and proposed instead an emblem representing the tablets of the Ten Commandments. The *Consistoire* said it was astonished that the Ministry should make such a choice, for not only was the Magen David unknown to its Algerian constituency but it also created confusion with the Masonic insigne.

That happened nearly twenty years after the Zionist movement had displayed the Magen David on its flag. The fascinating aspect of this controversy is that the (non-Jewish) Ministry considered the sign a Jewish emblem, but the (Jewish) *Consistoire* did not. Its members most certainly were aware of the Zionist movement and its flag. Was this a gesture of anti-Zionism? Possibly; but it is noteworthy that apparently the Jews in French North Africa did not relate to the Magen David at all, and certainly not for any ideological reasons.[9]

The sharpest judgment on the Magen David as a Jewish symbol was delivered by the Viennese

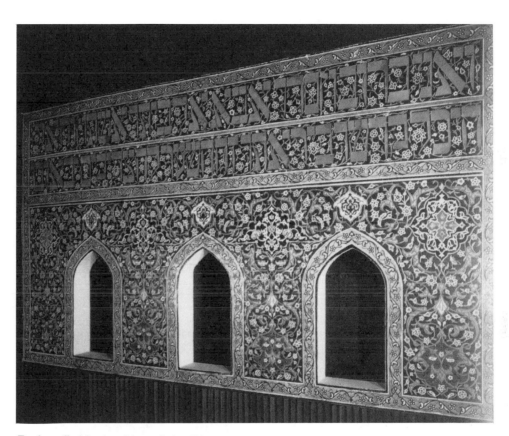

Torah scroll niches in a faience-tiled wall in a synagogue in Isfahan, Iran, c. 1550. The Jewish Museum, New York. Photo by H. R. Lippmann, New York, pictured in *Encyclopaedia Judaica*, vol. 15, plate 2, following p. 620. (*Courtesy of the Library of Congress*)

savant Moritz Güdemann, who as late as 1916 delivered himself of these disparaging words:

> Men of Jewish learning cannot accept the fact that the Jewish people would dig out of their attic of superstition a symbol or emblem that it shares with stables...[10]

Güdemann was a sound scholar who was well aware that the Magen David had been connected with magical beliefs and apparently continued in that fashion among non-Jews. His opposition was founded in part on purist considerations: something that was to represent the Jews had to have clear and unmuddied origins. (He may have had additional personal reasons for his opposition. For he, an Orthodox rabbi, was also a staunch opponent of the Zionist movement – and in his view it was no wonder that its adherents would like a symbol with such dubious antecedents.)

It is clear, then, that even at the beginning of the twentieth century the Magen David was still vigorously opposed and had not yet gained general acceptance.

NOTES

1 Wischnitzer-Bernstein, p. 25.
2 The Isfahan decorations may be seen in *Encyclopaedia Judaica*, vol. 15, col. 620.
3 Depicted in George Loukomski, *Jewish Art in European Synagogues* (London-New York, 1947), p. 180.
4 *Iggerot Yehadah Leib Gordon*, vol. II, p. 37 (Letter #225). His authority was the well-known scholar Jacob Reifman; see *Hashahar*, vol. II, pp. 435 ff. This opinion was shared also by the renowned Moritz Güdemann; see below p. 36.
5 *Graphische Requisiten*, etc. (Leipzig, 1870), vol. II, p. 213, note 238.
6 *Allgemeine Zeitung des Judenthums* (1900), p. 528.
7 Vol. VIII, pp. 251-252.
8 "Un modèle d'emblème spécial de nomière Maguen David." See *L'Univers Israélite*, March 15, 1917, p. 603 (Bordeau Ministériel No. B7 4/966, and Ordre No. 7/761 DA). The American War Department order was reported in the Yiddish dailies on July 26, 1918.
9 The lack of identification with the Magen David among Sefardic North African Jews could have been due to the fact that they were not reached by the symbolism radiating from Prague and Vienna. On the other hand, the Sefardic community in Jerusalem, which dwelt side by side with Ashkenazim, had adopted the Magen David as its emblem. See *Encyclopaedia Judaica*, vol. 14, col. 1078.
10 *Monatsschrift für die Geschichte, etc.*, vol. 60 (1916), p. 139. See also below, p. 73 note 6 on his view of the sign's origin.

5

Solomon and David

Pentagram

Our discussion in previous chapters has demonstrated both the sign's universal occurrence in earlier days and its predominant use as a protective device among Jews and Gentiles alike. Despite this, the hexagram managed in time to overcome this handicap and win the hearts of the Jewish people. When and how did this happen?

In the days when Talmud and Midrash were compiled, King Solomon's reputation as one who mastered the secret arts was very high. It was founded on the biblical tradition that the king was the wisest of all human beings, and that people came from afar to marvel at his wisdom. Quite naturally, legends grew up around him that ascribed to him extraordinary feats, one of which was his command of spirits and demons.

He mastered these, the tales went, with the help of a ring upon which the *pentagram* was incised, which enabled him to vanquish all demons and even obtain access to the Shamir, a worm with which stones could be cut with ease and which he used in the construction of the Temple.[1]

Christian and Muslim traditions also incorporated some of these legends, and in time the pentagram was known as the Seal of Solomon.[2] The Greeks too contributed to the reputation of the pentagram in that the Pythagoreans considered the sign to be a symbol of health.

In western Europe the pentagram's power was derived from a different source. There, preChristian Druids believed the sign possessed magical powers and it became known as "Druids' foot," which in Germany was later corrupted into *Drudenfuss* or *Trutenfuss*.[3]

But alongside this tradition went another: that Solomon's Seal had in fact not been a pentagram but a *hexagram*, and the latter, too, was often called by the wise king's

37

name. These conflicting traditions resulted in considerable confusion, so that, in studying the literature, one must make sure what the expression "Seal of Solomon" meant to the author: did he mean the pentagram or the hexagram? Thus, the thirteenth century Spanish scholar Abraham Abulafia used it for the latter[4] and an amulet from Ostia (the old port of Rome) for the former.[5]

Even many centuries later such usage persisted. A British traveler reported that Jewish women in North Africa "did make this mark on their chrysome cloths" and had it on their trunks in nails, and on their cupboards and tables;[6] and an Arabic author of the eighteenth century called the hexagram both Shield of David and Seal of Solomon.[7] In 1872 the German rabbi Leopold Stein, author of a widely read moral and ritual guide, referred to the pentagram as Magen David,[8] while fifty years later an Italian writer termed the hexagram "Il Nodo di Salomone."[9]

As late as 1939 one could encounter the Solomonic ascription in Britain, where the Zionist flag was described as featuring the Seal of Solomon;[10] and in Paris, during the German occupation, a newspaper so described the hexagram worn by Jews on their yellow armbands.[11]

Yet somehow, the name of Solomon invested the insigne, whether pentagram or hexagram, with only limited appeal. To be sure, the king's feats – 3000 proverbs, 1005 songs and many wives! – were fondly told and his magical powers willingly believed. Jews were not immune to superstition, and therefore a device which he used must have some power, even if only in reproduction. But Solomon had no call on the Jewish heart.

It was different with King David, and only when his name was regularly associated with the hexagram did it enter onto a path which eventually led to its acceptance as *the* Jewish symbol. For David's name evoked a different level of sentiment

in the Jew. David was the beloved of God whose Psalms spoke to every soul. David made Jerusalem the center of Jewish life and hope, and the Messiah would spring forth from his line. To this day popular folksongs carry his name as the symbol of redemption. "David, David, King of Israel, lives forever," one goes, and another sings of Elijah who will "soon come with the Messiah, descendant of David."

David was also a warrior and fought with forces terrestrial and extraterrestrial. He was said to have overcome the forces of the netherworld and battled with Margalittu, the ocean god of Babylonian mythology (possibly an aggadic reminder of the giant Goliath of biblical fame.) There existed also a legend that David's engineering of canals caused the earth's waters to break forth and that he stemmed them with the name of God written on a shard.[12] This name was inscribed on his shield, for did he himself not sing:

My *magen*, my mighty champion, my fortress and refuge! My savior, You who rescue me from violence![13]

Note that the text speaks of God as David's *magen*: David's protection is *God*, and not a shield of copper or bronze. Neither text nor ancient tradition asserts that the shield displayed a hexagram, and it is further noteworthy that none of the medieval commentators on the biblical verse, either in the *Book of Samuel* or *Psalms*, connects David's shield with the hexagram. Nor do the standard commentaries on the Talmud make this connection when the expression *Magen David* is discussed.[14]

How then did it come about? We cannot be sure, for there are divergent traditions on the matter.

In about 1300 a Spanish kabbalist, whose name was coincidentally also David (ben Yehuda) and who claimed to be a grandson of the great Nachmanides, wrote a commentary on the "Idra Rabba"

(Greater Assembly) which is part of the centerpiece of Jewish mysticism, the *Zohar*. In his work, called *Sefer ha-Gevul* (Book of the Border), the author reproduces the hexagram twice and each time with a divine appellation:

✡ Magen David Arikh Anpin
✡ Magen David Ze'ir Anpin

Arikh Anpin (literally, the long face) refers to God as long-suffering, while *Ze'ir Anpin* describes God as short-fused, that is, impatient. Both qualities in balance are charactcristic of the divine nature, for God's justice is impatient, while the quality of mercy implies forbearance. The hexagram shows both aspects in perfect harmony and is therefore a telling symbol of God's protective presence.[15]

This imagery was further strengthened by adding the name of a potent angel, called Taftafiyah. He was, so to speak, the one who mediated the magic qualities of

David's shield, and with the angel's name added the Magen David began to appear more and more frequently on amulets, along with a single triangle or an occasional pentagram. This was one tradition.[16]

But another did not know of the hexagram. Instead it related that *Psalm* 67 was inscribed on the shield and written in such a form that its words formed the likeness of the biblical candelabrum.

One purveyor of this idea was the Spanish rabbi Isaac Arama who supported his claim by eight verses from the psalm. These are recited during the period between Pesach and Shavuot when the protection of God against danger was deemed to be especially required.

The "Menorah Psalm" became a popular image; it was displayed in synagogues, on the title pages of books, and on charms. A sixteenth-century booklet says: "This psalm together with the menorah alludes to great things... and when King David went out to war he used to carry on his shield this psalm in the

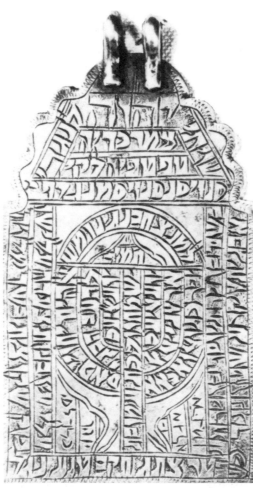

A menorah formed from the words of Psalm 67 and fashioned into a silver amulet in 19th century Persia. At the Ethnological Museum and Folklore Archives, Haifa. Photo by Oskar Tauber, Haifa, pictured in *Encyclopaedia Judaica*, vol. 11, col. 1364. (*Courtesy of the Library of Congress*)

form of a menorah engraved on a golden tablet, and he used to meditate on its secret; and thus was he victorious."[17]

This tradition raises the question why the menorah – here connected with David's shield – did not become the Jewish symbol *par excellence*. It was after all easily recognized as inherently Jewish. May we surmise that it failed of approval because it was too representational or too reminiscent of the Temple's destruction? Or was it too closely identified with the Levites rather than with the whole people, as Grunwald suggests?[18] We simply do not know.

We may note as an aside that there was at least one other symbol which was and remains popular: the lion. The British adopted it as their symbol, but the Jews, who were familiar with it much longer, did not. Biblical passages compare the power of Israel to that of a lion; it was the symbol of the tribe of Judah and bespoke royalty and hope. However, it was also widely

used in the Near East and therefore not easily isolated as specifically Jewish. Still, to this day, a pair of lions upholding the tablets of the Ten Commandments grace many if not most synagogue arks. The lion's protective function thus persists into our time, though this function is no longer recognized and the depiction of these lions is nowadays seen as purely "traditional."[19]

Let us return to the Menorah Psalm. The popularity of this image stimulated another tradition, one that believed in the hexagram as David's protective shield. It fastened itself to *Psalm* 121 which also has eight verses, suffused with promises of protection. Singled out specifically was the verse:

> The Lord will guard you
> from all harm;
> God will guard your life.

The words were often written on amulets in the form of a hexagram and became a popular protection for women in childbirth.

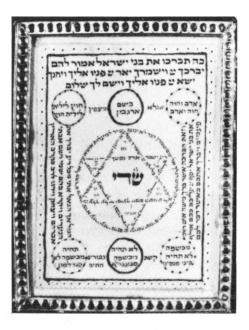

A Magen David fashioned from the words of Psalm 121 served as an amulet for women in childbirth in 18th-century Germany. Feuchtwanger Collection, Israel Museum, Jerusalem. Photo by R. Milton, Jerusalem, pictured in *Encyclopaedia Judaica*, vol. 6, col. 691. (*Courtesy of the Library of Congress*)

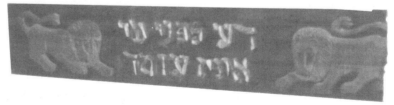

Lions of Judah and the saying in Hebrew which translates "Remember Before Whom You Stand" on a mantel over the ark at Beth Tikva Synagogue in Rockville, Maryland. (*Photo by B. Fishman*)

Belief in the miraculous power of the Magen David was further enhanced by tales of David Reubeni. He was a sixteenth-century adventurer who pretended to be a descendant of King David whose original shield he was said to have had in his possession. Though for some time this shield was displayed (so it was said) in the Bologna synagogue, it disappeared unaccountably, and with it the certain knowledge of the inscription or figure it displayed.[20] Such stories may not command the credence of the historian, but they are the stuff of folklore and, subsequently, of folk practice. This tale attests to the growing tradition of connecting David's name and shield with redemptive and protective power.

Such reports of David's power reached beyond the Jewish realm, which is not surprising. It was a time when magic and alchemy were widely practiced, and there was no reason why a Christian practitioner of the art should reject a proven Jewish secret. If the Magen David could indeed, as was claimed, create gold out of dross, the alchemist would gladly shelve his religious prejudice and use the Jews' device. Thus a German colleague published a volume entitled *The Secret Nature of the Shield of David*.[21]

This book portrayed the hexagram as the union of opposites, fire and water. Each of the triangles represented one of the elements, and their interlocking in the Magen David produced "fiery water," which was the key to the alchemist's craft. Perhaps he was encouraged by a verse in *Ecclesiasticus* (Ben Sira):

> He has set before you fire and water,
> Reach out and take which one you choose.[22]

The Christian alchemist would not likely have known that the Talmud had already discussed this matter, albeit without reference to any practical application. We read:[23]

Resh Lakish said: At creation God first created the heavens and afterwards the earth, but when erecting their structures God placed the earth first and then stretched the heavens above it.

Now what is meant by שמים (*shamayim*, heavens)? Rabbi Jose ben Hanina replied: read שם מים (*sham mayim*, water is there).[24]

Elsewhere we are told: [*shamayim* alludes to] אש מים (*esh/mayim*, fire/water). This teaches that the Holy One mixed them together and created the heavens from them.

Perhaps a Jew, familiar with the talmudic word play, did confide the secret to a Christian practitioner, and it is possible that the Magen David made its way into the magic of the outside world in some such manner. Superstition and magic know of no boundaries, and gullibility in these matters characterizes

the sophisticated as well as their counterparts.

Moritz Güdemann was right: the Magen David had dubious beginnings as a popular symbol,[25] but a people rarely charts its practices by such considerations. Thus also, the breaking of the glass at the end of Jewish wedding ceremonies has murky origins. Some scholars see it as the descendant of an ancient defloration symbolism, and others recount the belief that the glass breaking would scare away jealous demons hovering around the wedding canopy. No one thinks of these antecedents today when the custom is generally interpreted as recalling the destruction so often visited on the Jewish people, or as calling the couple's attention to the suffering of others and their own responsibilities toward them; or simply to remind bride and groom that life is not all joy.

Gershom Scholem made an additional observation. He stressed the influence of the Sabbateans on the development of the Magen David.

Sabbateans were the spiritual heirs of a seventeenth-century messianic movement led by Sabbetai Zevi. While the movement failed when the hero became a convert to Islam, it did not entirely disappear. A hundred years later it spawned another surge of messianic expectation when Jacob Frank stirred up many Jews in Turkey, Poland and Bohemia.

In western Europe, Sabbateans usually hid their sympathies for these sectarian beliefs in order to escape the censure of their coreligionists. Among those believed to be secret practitioners, none was more famous than Jonathan Eybeschütz, a rabbi in Metz and then Altona. His amulets were widely used and featured the hexagram, in the center of which often appeared a messianic allusion common to Sabbateans – מבד.

These letters stand for *M*(ashiah) *b* (en) *D* (avid), Messiah descendant of David. It was Scholem's thesis that the introduction of messianic elements into heretofore purely

Sabbatean Amulet

magical use greatly enhanced the popularity of the sign. He was probably right, but the influence of the Sabbateans must not be overestimated. Not all of them used the sign; the Frankists,[26] for instance, did not, though they proclaimed themselves the true heirs of Sabbetai Zevi.

But even without the likes of Eybeschütz, the name of David conjured up redemptive associations. After all, three times a day the Jew would pray:

> Speedily cause the descendant of David to flourish,
> and his horn be exalted by Your salvation,
> for we await Your salvation every day.

Which is to say that, once the name of David became more widely associated with the hexagram, it received a strong thrust forward. Mystery, magic, and salvation sent it on its way.

It was perhaps inevitable that attempts would be made to prove King David's actual connection with the sign. Thus it was claimed that \triangle, an old writing for ד (D), alluded to the king, and, when doubled and interlaced as a hexagram, became his signature. Others said that God had protected David from six sides, as is related in tradition – hence the origin of the symbol. Of such explanations there was, and is, no dearth.[27]

NOTES

1 The major source for these tales is *The Testament of Solomon*, a pseudoepigraphical book composed probably between 100 and 300 C.E. It is of Jewish origin but is interlaced with Christian material. On the legend of the Shamir, see Babylonian Talmud, Gittin 68a, which also says that Moses already had knowledge of the secret and cut the stones worn on the Ephod with it; see also Goldschmidt's commentary on Mishnah, Sota 9:12, note 171, where a Syrian source is quoted as saying that the Shamir was a rare gem which was so hard that it could cut all materials. The legends are summarized in L. Ginzberg's *The Legends of the Jews*, vol. IV (Philadelphia, 1913), pp. 149 ff.

2 *Hotam Shelomo* in Hebrew.

3 Further on this, see p. 72.

4 See Max Grunwald, *Jahrbuch für jüdische Geschichte und Literatur* (1901), p. 126.

5 Carl Watzinger, *Denkmäler Palästinas (Leipzig, 1933-35), vol. II, p. 112 note 4.*

6 Fanny M. Palliser, *Historic Devices, Badges and War-Cries* (London, 1870), p. 139 note 2.

7 Grunwald, p. 125.

8 *Die Schrift des Lebens* (Mannheim, 1872), vol. I, p. 155 (note).

9 However, at the same time, suggestions were made in Florence for the founding of a Red Magen David Society that would feature the hexagram. See *Jüdische Wochenschrift*, Nov. 25, 1914.

10 Wheeler-Holohan, p. 17.

11 *Paris-Midi*, June 8, 1942.

12 Babylonian Talmud, Sukah 53a-b.

13 II Samuel 22:2, repeated in Psalm 18:3 with some variations.

14 See, e.g., Rashbam's otherwise extensive remarks on Pesahim 117b. As mentioned earlier, one of the traditional Haftarah blessings praises God as *Magen David*, i.e., David's protection. The blessing is traced to Rabba bar Shila, a Babylonian teacher of the fourth century C.E.

15 Scholem (*The Messianic Idea*, p. 269) notes, however, that some manuscripts have the pentagram and not the hexagram.

16 In later amulets Taftafiyah came to be replaced by Shaddai (Almighty).

17 Quoted by Scholem, p. 270. It should also be noted that illuminated manuscripts of the fourteenth and fifteenth centuries often depict David with a *lyre*; see Israel Abrahams, in *Festschrift für Israel Lewy* (Breslau, 1911), p. 283.

18 In Breier, Eisler and Grunwald, *Holzsynagogen in Polen* (Vienna, 1934), Appendix p. 22.

19 See the discussion in Goodenough, vol. 7, pp. 29 ff., who devotes a chapter to the lion in Jewish iconography.

20 Joseph ben Yitzhak Ha-Sambari (Egypt, seventeenth century), quoted by A.S. Eshkoli, *Sippurei David Ha-Reuveni* (Jerusalem, 1940), p. 165.

21 Published in Berleburg, 1724.

22 15:16. See also *Wisdom of Solomon* 16:18-23 on the interaction of fire and water.

23 Babylonian Talmud, Hagiga 12a.

24 Because rain comes from above.

25 See above, Güdemann, 36.

26 Followers of Jacob Frank who proclaimed himself as the Messiah.

27 See S. Nascher, *Allgemeine Zeitung des Judenthums* (1900), p. 576; I. Shapira, *Ha-Me'assef*, vol. 18 (1912), p. 12. The talmudic tales are found in Babylonian Talmud, Sanhedrin 95a, but the Talmud itself makes no mention of the signature.

6

Mystical Musings

It would be a gross error to judge the mystical searchings known as Kabbalah by the magical practices which followed in its train. Underlying the Kabbalah was a profound commitment to the all-powerful presence of God who was waiting for Israel to devote itself heart and soul to reach the Divine Throne. But the road was hard and long, and only the most devout were able to penetrate some of the veils that shrouded the Mystery.

In this search they were aided by a study of the *Zohar*, the rich mystical commentary on the Torah, and by great teachers like the Ari, whose disciples charted ways of understanding the divine emanations and their secrets. At the end of the road, they believed, lay the arrival of the Messiah, whose way would be prepared by the prophet Elijah. Jewish mysticism had ultimately a redemptive, messianic character, and its devotees fervently hoped that these labors would hasten the coming of the end-time.

It was inevitable that the noble purposes of the Kabbalah would also spawn attempts to make practical use of the insights which its students had gained. Such "practical Kabbalah" (*kabbalah ma'assit*) concentrated especially on exploring the true essence of the Almighty, for such knowledge would vouchsafe power over the demonic forces which constantly opposed and thwarted God.[1] These forces inhabited the murky spirit world, and had their counterpart in the human persecutors who embittered the life of Israel. One should not forget that behind all personal hopes to gain access to secret knowledge was also the desire to bring nearer the day when the prolonged sufferings of Israel would finally be ended.[2]

The practical Kabbalah was especially fascinated by the problem of how to learn the secret name of God which was hidden behind the

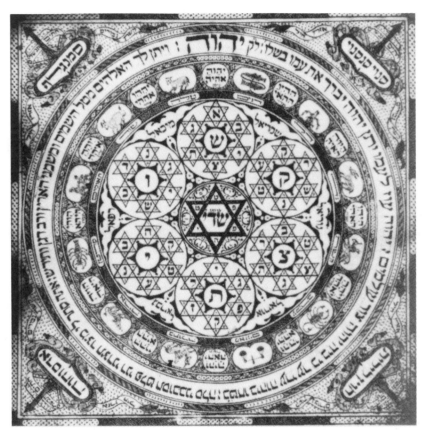

A kabbalistic drawing from 17th-century Italy which prominently features the Magen David. Photo by Manning Bros., Highland Park, Michigan, pictured in *Encyclopaedia Judaica*, vol. 6, col. 692. (*Courtesy of the Library of Congress*)

enigmatic letters יהוה (YHVH) of the Torah – a name which Jews had not pronounced since the Temple was destroyed. For a knowledge of the Divine Name would be equivalent to knowing the Divine Nature. Already Moses had attempted to gain access to it when he asked God to reveal The Name. But God had demurred, fearing that, through the knowledge of The Name, Moses would acquire divine powers. Therefore, to Moses' inquiry after the Name, God gives a circular answer: "I AM WHO I AM." Moses must be satisfied; he must understand that this God who has addressed him at the burning bush cannot be fully understood nor, like ordinary deities, be manipulated.[3]

But the mystics refused to understand God's answer as a rejection of Moses' quest. Rather, they saw it as a challenge to their own imagination. They came to think that the four-lettered Name (the so-called Tetragrammaton) really stood for many more letters and set out to discover them. Such investigation

resulted in magical experiments, among which the fashioning of amulets had a prominent place. They were primarily tools to ward off demonic danger through the use of the Divine Name, assisted by the names of angels and mystical formulae.[4]

Along a similar vein, the mystics sought to know God's "Great Seal" (called Iska Rabba) whose use would bestow power and protection. Here, Jewish and non-Jewish mysticism clearly intersect. For when one takes the Hebrew letters of Iska Rabba

אסקא רבא

and reads them backwards, one obtains

אבראקסא (Abraksa)

This Abraksa was very much like "Abraxas," a well known talisman among the Gentiles who derived its name from a Greek divinity.[5] Now in Greek as in Hebrew, the letters add up to 365,[6] which was seen as added proof that the Great Seal had universal potency.

It was this kind of speculation that surrounded the symbolism of the Magen David. One of the Middle Ages' more obscure (yet nonetheless famed) mystical works was *Sefer Raziel*, so named after an oft-imagined member of the angelic host. It showed the Magen David with the Divine Name at the center, and thus its potency was *ipso facto* assured.[7]

According to H.A. Winkler,[8] the hexagram was further enhanced through extraneous cross-circuits, for some Arabic authors propagated the idea that the sign was a configuration of letters. Among Jewish students this strengthened the likelihood that the saying "God's seal is truth" might allude to the hexagram, for אמת (truth), if written in old Hebrew script, could be shaped into two interlaced triangles.[9]

A final example from this arena relates to the ever-present hope of the Jewish people for speedy and miraculous redemption. A talmudic legend, to which we referred earlier, told how David had caused a shard upon which God's name was written to be cast into the water, and how thereby he had stemmed a flood.[10] From here to the belief that the king's shield and sign could also work great wonders was but a small step. The double configuration was propitious. David was God's agent in the protection of Israel, and the Magen David its symbol, an idea which was vividly expressed on a mezuzah container from Carpatho-Russia. Its inscription, "Protector of Israel's Doors," is placed in the center of a Magen David.

Crafted in the nineteenth century, this mezuzah[11] reflects the old belief that the scroll's own protective power could be made more effective through the presence of David's sign. Many Jews who craved protection wore a pendant with the Magen David as a kind of amulet.[12]

NOTES

1 Jews were of course not alone in this search. Gnostics, Christians and Muslims also pursued such inquiries. The advent of modern times was caused by another kind of exploration of the mysteries of existence, one which took the road of scientific rather than mystical inquiry.

2 The legend of the Golem (see below, p. 57) makes it clear that its main purpose was to succor a stricken Jewish community.

3 *Exodus*, chapter 3.

4 An amulet might, for instance, serve to protect a woman from evil spirits wishing to harm her during childbirth. (An illustration of such an amulet may be seen on page 41.) Similarly, in Christian folklore, Satan would be constrained when confronted with the cross.

5 The Jewish mystics connected the name with Abir Shesh, an angel with six wings as observed by the prophet in his vision (*Isaiah* 6:2).

6 Adding up letters was an important aspect of the mystical enterprise. Each letter in the alphabet has a numerical value, e.g., א stands for 1, ב for 2, and so on. Thus the thorn bush at which Moses received his revelation is called הסנה , a word whose letters add up to 120. Mystics saw in this a hint that Moses would live to be 120 years old. Such numerological investigations went under the name of *Gematria*.

7 See further Grunwald, in Breier, Eisler, Grunwald, Appendix pp. 20-21.

8 *Siegel und Charaktere* (Berlin, 1920), p. 121.

9 Babylonian Talmud, Shabbat 55a. But Rashi (tenth century) explains the talmudic saying quite differently: the word אמת consists of the first, middle and last letters of the alphabet, denoting God as first and last and central pillar that upholds the universe.

10 Sukah 53a-b; see above, p. 38.

11 Pictured by Wischnitzer-Bernstein, p. 76. The mezuzah was part of the collection of the Berlin Jewish Museum, later destroyed by the Nazis.

12 Nowadays, the Magen David is more often worn as a badge of Jewish identity.

7

The Prague Connection

A porcelain Passover plate, ca. 1900, from *The Precious Legacy: Judaic Treasures from the Czechoslovak State Collections*, Photo by Quicksilver Photographers, Washington, D.C. (*Courtesy of* SITES)

Few Jewish communities could match the capital city of Bohemia in its amplitude of highs and lows, achievements and miseries.

Prague lay at the crossroads of East and West. From the middle of the fourteenth century on it was, and remained for some three hundred years, the capital of the Holy Roman Empire. Here, Christians fought over the religious teachings of Jan Huss who was burned at the stake for his heresies.[1] Here, in the seventeenth century, the Swedish penetration into central Europe came to a halt, which hastened the end of the Thirty Years' War and divided the continent into Protestant and Roman Catholic regencies.

Jews had lived in the city for a long time, but had done so in a state of constant insecurity. Shortly after they had settled in appreciable numbers they were ravaged by the "pious heroes" of the 1096 crusade who found it easier to kill unarmed Jews than armed Saracens. Not long after the community had somewhat recovered, the whole Jewish quarter burned to the ground and its hapless inhabitants moved across the river. For a while they flourished, only to be humiliated and expelled, readmitted and expelled again with terrible regularity.

Yet the Jews returned, for more often than not other habitats were equally unattractive or other rulers closed their borders to the "Christ-deniers." And when they returned to Prague they experienced, in the interstices between persecutions, periods of well-being and great spiritual creativity.

The year 1338 had seen a particularly vicious persecution, but Jewish fortunes turned decidely for the better when Charles IV became King of Bohemia in 1346 and nine years later, acceded to the throne of the Holy Roman Empire and made Prague its capital. The emperor was most comfortable with well-defined legal procedures and

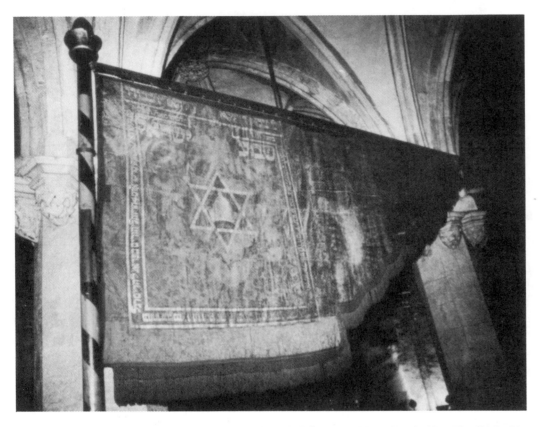

The flag of the Jewish community which hangs in the Altneuschul, featuring a Magen David with a "Swedish hat" in its center. From *The Precious Legacy: Judaic Treasures from the Czechoslovak State Collections*. (*Photo by permission of* SITES)

promulgated a constitution for the empire (the so-called Golden Bull). He also found it prudent to issue writs of protection for the Jews in his realm. This protection came at a time when Jews were excluded from England and largely from France as well. Charles assured the Jews of his benevolence and, as a token of his regard, he gave them leave to display a distinctive flag of their own. Red colored, with a yellow Magen David, it was subsequently on view in the city's premier synagogue. When after some years it fell into disrepair it was replaced with a replica and this banner of 1716 is still to be seen in the Altneuschul.[2]

Here then was a Jewish community which, in the middle of the fourteenth century, identified itself officially with an emblem showing a Magen David surrounded by Hebrew script.[3] Probably the sign's presumed protective power made it especially attractive.

Gershom Scholem raised the question whether the Prague banner

was created by the Jews themselves and at their initiative or was issued to them by royal fiat. He favors the former as more likely because of the Hebrew inscriptions.[4] But the latter possibility has credence also, because other marks of Jewish identity, like hats, were usually prescribed by Gentile authorities. (Another theory holds that the flag was an import from southern Russia where the Khazars, a people converted to Judaism, were said to have used it.[5] This is an intriguing suggestion but, alas, brought forward with insufficient supportive data.)

The identification of the Prague community with the Magen David, once begun, became firmly established. Two hundred years later another emperor, Rudolf II, presented the city's Jewry with a flag fashioned with a hexagram and Hebrew script. The recipient was Mordecai ben Samuel Meisel, who at the time was Prague's most prominent Jewish layman and the emperor's financial adviser. He was

a man of great wealth and during the Turkish war was of considerable service to the crown. When in 1597 he completed the building of his own synagogue (to this day known as Meisel's shul) the emperor gave him a flag as a gift. In this instance it may be assumed that the recipient had a hand in creating or ordering the design.[6]

Both synagogue and flag survived, though Meisel's fortune did not. After Meisel's death the authorities summarily seized it for their own benefit. If they could no longer have Meisel's advice, at least they could have his money.

In addition to the Magen David and the Hebrew text, the Meisel and Altneuschul flags have one other feature in common. In the center of both hexagrams is the picture of a hat. How this image came to be incorporated into these flags has given rise to much speculation. A modern publication which tells the history of the Prague ghetto relates the following:[7]

We have to transport ourselves back into the year 1648, when the Thirty Years' War came to an end. At that time the Swedish general Koenigsmark invaded Bohemia, advanced on Prague and laid siege to it.... Colloredo, the defender of Prague, sent a messenger who had to pass the enemy lines in order to obtain relief.... He was a Jew, accomplished his task, and the emperor's army arrived in Prague in time to prevent the Swedish intent to encircle the city completely.

In addition, the Jews distinguished themselves in the city's defense. While the Gentile population sustained the loss of 113 men, no fewer that 22 Jews sacrificed their lives, a disproportionately high number. When the news reached Prague that a peace treaty had been signed at Münster and Osnabrück,[8] Emperor Ferdinand rewarded the Jews of Prague with

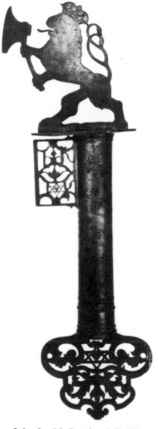

Emblem of the Jewish Butchers' Guild, made of cast and engraved pewter in Prague, 1620, from the catalog of *The Precious Legacy: Judaic Treasures from the Czechoslovak State Collections.* Photo by Quicksilver Photographers, Washington, D.C. (*Courtesy of* SITES).

various privileges: They would have greater access to many occupations hitherto closed to them and would have the right to settle in the larger cities. Also, the right to display the old flags was renewed – only now a hat was displayed in the center of the Magen David. Quite clearly, says tradition, this was a "Swedish hat" and as such a remembrance of Jewish bravery. Henceforth the old flag in the Altneuschul was also referred to as the "Swedish banner."

The tale is probably more legend than history. It posits that the "Swedish hat" was superimposed on the old flags which until then did not have it. Furthermore, there are Gentile banners from that era that lack the hat. Why would the Jews alone be asked to show it?

The answer lies close at hand. The hat depicted on the Altneuschul and Meisel flags was a "Jews' hat." Forcing Jews to wear special headgear was an old European custom, which went along with their distinctive garb and badge.[9]

The hat in the Prague Jewish banners made sure that Christian neighbors would not be tempted into treating Jews like anyone else. The "Swedish hat" was simply an extension of discriminatory practice. This is proven beyond doubt by the fact that the much older Hungarian flag (of 1475) also shows a hat, and that flag certainly could not evoke any Swedish association.[10] As early as 1322 a seal from Constance in southern Germany portrays three Jewish hats of the same shape found later in Prague. We must therefore regretfully conclude that the emperor did not have the Jews exhibit a new flag, but rather one of the older ones, both of which had always displayed the customary Jews' hat.[11]

If this was so, then the presence of this image would underscore what is particularly relevant for our investigation, namely, that the hexagram by itself was not yet the emblem which would at once identify the flag as Jewish. The hat fulfilled that function – hence its

depiction on the old banners. Of
course, as time passed and special
Jewish hats disappeared, the hat on
the flag no longer carried its old
degrading connotation. It was then
that the interpretation of the
"Swedish hat" gained currency.
Now there was every reason to dis-
play the flag proudly on every state
occasion, and it was said that it
took thirteen strong men to carry it
and keep it upright.

Thus, the hexagram had become
the emblem of Prague Jewry and
the name Magen David was firmly
affixed to it. When the astronomer
and chronicler David Gans died in
1613 his tombstone was decorated
both with the hexagram and his
name – a particularly appropriate
memorial since the scholar's last
book was entitled *Magen David.*

A hundred years later the sign
was in fairly wide use in Prague,
more so than in any other impor-
tant community of the time. It was
placed on top of the Jewish city
hall and of the Meisel synagogue
and appears on Rabbi David Op-

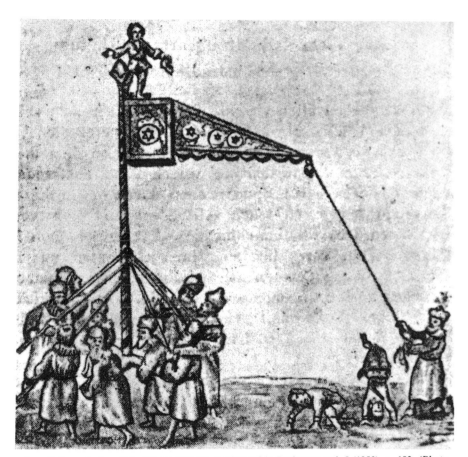

An artist's rendering of the Prague banner, as pictured in *Reshumot, vol. 5 (1953), p.* 102. (*Photo courtesy of the Library of Congress*)

Tombstone of David Gans, d. 1613. From the catalog of *The Precious Legacy: Judaic Treasures from the Czechoslovak State Collections*. (*Photo by permission of* SITES)

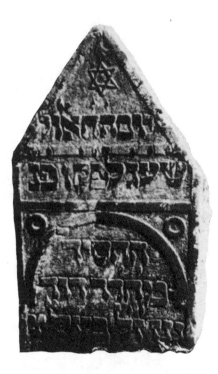

Tombstone of David Oppenheim, d. 1736. From the catalog of *The Precious Legacy: Judaic Treasures from the Czechoslovak State Collections*. (*Photo by permission of* SITES).

penheim's instrument of appointment as chief rabbi in 1702, as well as on his tombstone.[12]

Legend too helps us to trace the popularization of the Magen David in Prague. While the city's rabbis often enjoyed a wide scholarly reputation, none was greater than that of Rabbi Judah Loew ben Bezalel, chief rabbi of Prague at the beginning of the seventeenth century.[13] He was a talmudist, philosopher, mathematician — and also student of the Kabbalah. Known by his acronym as the "Maharal,"[14] he enjoyed enormous respect far beyond his own community. In 1592 the Emperor Rudolf granted him a personal interview, an unheard-of privilege accorded to a Jew.

Stories were told about this man which exalted his piety as well as his knowledge of the secret arts. Chief among these tales was that of Maharal's creating a living being out of clay. He knew the right prayers and combinations of letters and devices, and when the so-called

Golem was at last fashioned it was brought to life by inscribing the letters אמת (*emet*, truth) on its forehead. Alas, the story goes, the Golem began to run amok, whereupon the Maharal was forced to remove the א from its brow, which left the letters מת (*met*, dead) and thereby reduced the Golem to dust.

Historians agree that the Maharal never engaged in such activities and they surmise that these legends were affixed to him after his death. But such stories could arise only in a climate in which the arts of the practical Kabbalah were legitimized sufficiently so that the name of one of the famed scholars could be attached to them. The belief in the Magen David's magical qualities was thereby enhanced, and especially so in Prague whose shining light the Maharal had been.

Let us briefly review the special relationship of Prague to the Magen David.

The fourteenth century marked the beginning of a new period in the Magen David's history, when a whole community was officially represented by it on its flag. Had it happened elsewhere this might have been of minor importance, but since Prague was the seat of the Holy Roman Empire and the Jews lived under the Emperor's special protection, the sign hitherto used primarily on amulets and charms assumed a prestige which up to then it had not enjoyed. Later, the predilection for Kabbalah, which Prague's most famous rabbi was believed to have cherished, reinforced the people's faith in the efficacy of the Magen David. This may explain why in 1642 the communal seal of the Prague Jewish community showed the Magen David, with the six letters מגן דוד inscribed in the six corners of the hexagram, in addition to the famous hat in the middle.

This does not mean that thereby the Magen David had established its singular role as *the* representative symbol of Jews; far from it. But it was on its way.[15]

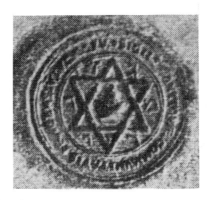

Seal of the Jewish community of Prague, from *Reshumot* vol.5 (1953), p. 96. (*Photo courtesy of the Library of Congress*)

Compulsory headwear for medieval Jews. Note the similarity to the presumed "Swedish hat." From Singermann (see note 9), p. 51.

NOTES

1 His *auto-da-fé* took place in Constance in 1415.
2 The flag itself proclaims that it was issued in 1357, but all records suggest an earlier date, probably 1354. Grunwald claims that it was issued six years earlier (Eisler, Breier, Grunwald, p. 29).
3 It features the *Shema:* "Hear O Israel, the Lord is our God, the Lord alone" (or "the Lord is One").
4 *The Messianic Idea*, p. 276.
5 O. Neumann, in *Jüdische Familienforschung*, vol. 8, p. 49.
6 Its picture may be seen in *Encyclopaedia Judaica*, vol. 6, col.1334.
7 J. Lion and J. Lukas, *Das Prager Ghetto* (Prague, 1959), pp. 34 ff.
8 Cities in Westphalia, in western Germany. The treaty was signed in October 1648.
9 The scandalous distinction of having been the first to force Jews to wear special clothing or marks belongs to Pope Innocent III who believed that Jews deserved to be treated with contempt. At his direction the fourth Lateran Council in 1215 directed that Jews everywhere had to be marked, lest innocent Christians might be led to mingle too closely with them. The "mark of Cain," as it was called, was at first a wheel affixed to breast and back, then a circle and afterwards a doughnut-like ring. Colors and shapes varied from country to country. In time, yellow - to symbolize envy - came to predominate. Thus, in 1555, Pope Clement VII decreed a yellow hat for Jewish males and a yellow headcloth for females. Their dress, too, assumed particular "Jewish" features. (See the study by Felix Singermann, *Die Kennzeichnung der Juden im Mittelalter* (Berlin, 1915).)
10 See below, p. 72.
11 Lion and Lukas, p. 36, concede that some historians believe the "Swedish" hat to have been a Jews' hat. There was also a tradition that the hat (whatever its meaning) had replaced a pentagram or *Drudenfuss*, but there is no evidence for it. Such a tradition existed also with respect to the old flag in Ofen (today's Budapest); see below, p. 72.
12 It should be noted, however, that eighty years before, the letter of nobility issued to Jacob Bassevi von Treuenberg showed three *pentagrams;* see Scholem, p. 277. Also, a depiction of a Jewish procession in honor of Archduke Leopold shows a banner on which the letters דגל (*degel*, flag) are shown, and not the Magen David. But the author was Johann Jakob Schudt, a Christian historian, whose depiction of Jewish life is not always accurate and sometimes, as likely in this case, quite fanciful; see the illustration in *Jewish Encyclopedia*, vol. X, p. 154.

13 Other well-known rabbis were Ephraim
 Solomon of Luntschitz, Isaiah Horo-
 witz, and Yom Tov Lipmann Heller.
14 Drawn from the first letters of מורנו הרב
 רבי ליוא . He lived 1529-1609.
15 A historical aside: When, in 1920,
 Prague — now the capital city of
 Czechoslovakia — adopted a new civic
 emblem, it incorporated into its design
 the flags of all the municipalities that
 had become part of the metropolis.
 Among these was the Altneuschul flag,
 its red color and golden Magen David
 clearly discernible. Today the city has a
 negligible Jewish population but is rich
 in Jewish memorabilia: in tombstones,
 Torah curtains and memorial walls
 where the names of all those who
 perished in the days of the Nazis are
 recorded. The two flags have also
 escaped destruction and these two
 landmarks in the history of the Magen
 David have been preserved. The
 Altneuschul banner stands in its place in
 the synagogue; the Meisel flag is in the
 State Jewish Museum.

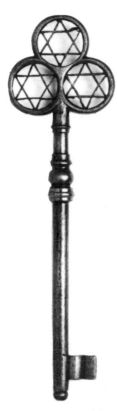

Synagogue key from the late-19th-century
Prague. From *The Precious Legacy: Judaic
Treasures from the Czechoslovak State
Collections*. (*Photo courtesy of* SITES)

8

The Magen David in Vienna

Seal of Viennese Jewish community, from *Reshumot*, vol. 5 (1953), p. 97. (*Photo courtesy of the Library of Congress*)

The Jewish community of Vienna had a brilliant history and produced its share of scholars. But it was also repeatedly caught in the crossfire of political tensions and economic upheavals, which had the same unfortunate result: the Jews were plundered and expelled; then (because their skills were needed) readmitted, only to be plundered after a while and expelled again. In the thirteenth and fourteenth centuries things had gone rather well for them and the privileges granted them by Emperor Frederick II exercised some protective power.

From the fifteenth century on, the Viennese community lost its stability. The year 1421 saw a series of cruel persecutions, and a hundred years later only twelve Jewish families were left in the city. Then the numbers slowly grew again, and when there were enough of them they were confined to a ghetto.

In the 1650's the head of the Viennese Jewish community was Zecharyah ben Issachar bar Halevi, known as Zecharyah Meyer (or Mohr). He was a benefactor of communal institutions, having built a study house and a synagogue. When the community adopted a seal it chose the hexagram as its emblem.

Why this choice? The most likely answer is that the Prague community had already introduced the sign on its own seal. The Prague seal which is extant dates from 1642[1] and the Viennese seal from 1655. Most likely, the Jews of Vienna followed the Prague model.

There may be an additional, more personal reason, to be found in the familial circumstances of Zecharyah Mohr. His son Joseph had married into the family of Lezer-Aron, who was a provisioner for the army and had rendered valuable services to the government. As a reward he had received permission to display a heraldic emblem. Lezer-Aron had chosen the hexagram, possibly

A boundary marker from Vienna, 1656. From Staedtisches Museum, Vienna; pictured in *Encyclopaedia Judaica*, vol. 6, col. 692. (*Photo courtesy of the Library of Congress*)

because of the Prague precedent. When the time came to adopt a seal for the community, Mohr may have looked to the heraldic symbol of his son's family, fortified as it was by the Prague precedent.

In 1656 a boundary between city and ghetto was fixed and a marker was fashioned which separated the two communities. The Christians were identified by the cross and the Jews by the hexagram. This was the first time that the hexagram functioned as a counterpart to the Christian cross and thus assumed a clearly religio-cultural aspect.

Thirteen years later, in 1669, a new expulsion of Vienna's Jewry began. All Jews who could be classified as poor were driven out and in the following year a like fate befell the rest, their money proving to be an impermanent defense against bigotry and a stimulus for their oppressors' greed. The refugees fled to the countryside and to more hospitable communities in Moravia as well as southern and central Germany.

The flight had one consequence which concerns us here: it spread Viennese Jewish customs abroad. Among them was the use of the Magen David, for the symbol went with them.

It is interesting to note that it appeared in Kremsier (Kromeriz) in Moravia where Joseph Mohr had fled and here too it became the community seal. Other refugees took the symbol to such places as Nickolsburg, Eibeschütz, Eisenstadt and Przedborz (Poland). Thus, the Viennese Jewish dispersion of 1669-1670 had the effect of introducing the Magen David to many new places.

We cannot, however, trace the path of its migration to other centers of Jewish life. We do know that in the latter part of the seventeenth century the symbol also appeared in Amsterdam, now one the great centers of European Jewry. The official seal of its Ashkenazic community featured the six-pointed star – *with the "Swedish hat" at its center*! –

strong proof for the Prague origin of the seal. But, as everywhere else in Europe, the symbol itself was already known in Amsterdam before the Prague-like seal was introduced. As early as 1572 we find the Magen David on silver tokens which were needed to gain entrance to the ghetto.

Frankfurt was another important Jewish community and here too the hexagram had already achieved some form of communal recognition. It was considered a seal of protection after the riots instigated by the odious Vincent Fettmilch (in 1614) resulted in a temporary exile of the Jews.

The mystical uses of the hexagram and its connection with the redemptive significance of David's name had by now found fertile soil in many places. In Prague the emblem had been given official status; Vienna and Amsterdam followed, and one may say that with this threesome of renowned Jewish communities elevating the symbol to preeminence, it had found a notable place in Jewish life.

To be sure, the symbol had appeared in official capacities before, as for instance in fourteenth-century Portugal where Jews wore it as a distinctive badge,[2] and possibly a century later in Hungary (though the symbol placed on a flag there was most likely not a hexagram but a pentagram). However, these occurrences were isolated and had no traceable effect on other European communities.

Hence the assertion by Scholem that Prague is to be considered the starting point of the symbol's ultimate ascendancy has much to commend it. At the same time, the role which Vienna played in this progression cannot be underestimated. For the use of the Magen David as both a communal and a religious symbol may be traced to the setting of the abovementioned boundary stone, an event whose importance was stressed by Paul Diament.[3]

To sum up: There had been widespread traditions which stressed the potency of the Magen David, but they needed prestigious approval to have it gain common acceptance. When in the seventeenth century official recognition was accorded to the symbol in Prague, the capital of the Holy Roman Empire, then in Vienna, from which it was spread abroad by the dispersion of its Jews, and thereafter in Amsterdam, the symbol had achieved a series of signal breakthroughs.

But it would take another two hundred years or more before it emerged as the universal and undisputed badge of Jewish identity.

NOTES

1 See above, p. 57.
2 Singermann, p. 27 note 4.
3 *Reshumot*, new series, vol. 5, pp. 93-103.

9
The Printed Page

Reading and writing was once the prerogative of clergy and nobility. The average person stood in awe before the learned, but did (and could) not emulate them. Jews were a remarkable exception to this near-universal condition. Four years before the Romans destroyed the Temple and the Jewish state in 70 C.E., general education was introduced in Judea. Most probably the edict was not at once fully operative, especially when the war absorbed the vital energies of the people, but then and thereafter every Jewish boy became the potential recipient of the written tradition. Girls were not considered tar-

gets of such education, though they could and often did acquire learning individually. On the whole, women were the chief transmitters of *non*-literary teachings and customs and brought up their children to know and observe them.

Still, one must remember the circumscribed impact to which the written word was limited before the printing press was invented. Manuscripts were few and precious; hence the appearance of the Magen David in hand-written literature had by its nature a limited effect on folklore. This is one reason why, until the arrival of the printed word, no single symbol emerged as

representing the Jewish faith and people. (Another was the ghettoization of the Jews. In their enclosures they needed no identification which would proclaim their places and utensils as Jewish. And on the outside, their hats, garb and often the circle badge proclaimed their identity.)

There had been banners when the Jewish commonwealth was still in existence, but no regnant symbol. After its destruction some images obtained considerable currency, chief among them the Temple menorah (as depicted on the Arch of Titus), the lyre (David's instrument, an oft-repeated illustration),

Magen David used as a printer's mark in *Seder Tefillot*, the first Hebrew book published in central Europe (Prague, 1512). From A. Yaari, *Hebrew Printers' Marks from the Beginning of Hebrew Printing to the End of the 19th Century* (Jerusalem, 1943), as pictured in *Encyclopaedia Judaica* vol. 6, col. 691. (*Photo courtesy of the Library of Congress*)

grapes (recalling the natural wealth of the land of Israel), or lions (often shown as guarding the holy ark or the tablets of the commandments). These lions could be seen by everyone in the synagogues, but other symbols were confined to manuscripts. The wider Jewish public, even though schooled in reading, came only occasionally into contact with such depictions.[1]

Abstract symbols, such as pentagram and hexagram, fared no better. Christians had their flags and heraldry emblazoned with a cross; Muslims had their banners showing stars and crescents; Jews, having no state of their own, displayed as identifying marks only those forced upon them by their masters. But once the printing process made its way in the second half of the fifteenth century and Hebrew books were published, illustrative symbolism had a chance to become popular.

The printing of the first Hebrew book in Prague is of particular interest. The dedication page

describes the community as "an adornment to all the cities of the earth." Six associates participated in the issuance of the prayer book which was called *Seder Tefillot* and appeared on the eve of Hanukah in 1512. The printer's mark featured a hexagram with a shield in the center.

It may be assumed that the official status the Magen David had already acquired was a major reason for its printed usage. At any rate, books published in Prague made their way to many communities.

But one cannot be sure about the importance of this influence, for some books printed earlier in Lisbon and Constantinople also showed the Magen David. Still, the Prague connection provides a more likely explanation for the *dissemination* of the symbol, and suggests the reason why one of the most prominent Jewish printing houses in Europe came to use it as its regular emblem. The establishment was owned by the Foà family which

originated in Italy and branched out to Holland. Its career spans more than 250 years, and its influence in popularizing the Magen David is beyond question. The Foà name made the sign familiar to many Jewish readers.

Tobias Foà published in the middle of the sixteenth century in Venice and Sabionetta, and fashioned the Magen David into an important part of his logo. Lions were shown supporting the emblem, and in one instance it is depicted as part of a palm tree, together with a quotation from the 92nd Psalm, "The righteous shall flourish like the palm." Printed around the Magen David are four biblical quotations each containing the word *magen*.

When the family built a synagogue they pictured the symbol there as well. Isaac Foà used it in the latter half of the eighteenth century, and Gad ben Samuel Foà in the early nineteenth, while Nathaniel Foà had already transported the symbol to Amsterdam.

About that time Israel Jaffe, who

Marks used by Tobias Foà in Sabionetta, 1551-1559, as pictured in A. Yaari, *Hebrew Printers' Marks from the Beginning of Hebrew Printing to the End of the 19th Century* (Jerusalem, 1943), p. 13. (*Photo courtesy of the Library of Congress*)

Mark used by Nathaniel Foà in Amsterdam, 1702-1715, as pictured in A. Yaari, *Hebrew Printers' Marks from the Beginning of Hebrew Printing to the End of the 19th Century* (Jerusalem, 1943), p. 56. (*Photo courtesy of the Library of Congress*)

published in Kopys, Russia, copied the Foà emblem for his own books – but it is noteworthy that other printers who also copied the Foà logo omitted the Magen David.[2] We do not know their reasons. Perhaps it was simply aesthetics, perhaps other considerations were at play. Certainly the Magen David was still only an occasional emblem, although its acceptance was growing. It is noteworthy that a Venetian printer, Abraham ben Shabbetai ha-Cohen, called the hexagram "Magen Abraham" in 1719. The play on his own name is obvious, but he probably would not have made it if the name Magen David had been firmly established at that time. Apparently it was not.

NOTES

1 Thus, the hexagram "appears occasion-
ally — even before the rise of printing
— in Hebrew manuscripts that were
written in Italy and Germany in the
fourteenth century.... An illustrated
Haggadah of the early fifteenth
century... contains the drawing of a
man holding a circular *matzah* [un-
leavened bread] inscribed with a very
elaborately executed, double-lined and
intertwined Shield of David" (Scholem,
p. 274 f., who also cites other, similar
occurrences). J.D. Eisenstein, *Otzar
Yisrael* (under "Magen David") refers
to an eleventh-century manuscript of
Seder Eliyahu Rabba ve-Zuta which
contains the Magen David, as does a
coin of the same time which Eisenstein
possessed but does not further identify.

2 Abraham Yaari, *Daglei ha-madpisim
ha-ivriyim* (Jerusalem, 1944): *idem,
Kiryat Sefer*, vol. 18, pp. 67-99.

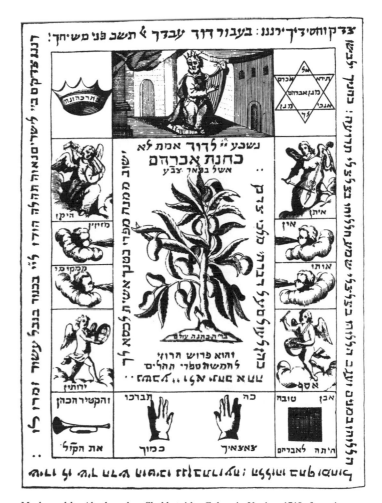

Mark used by Abraham ben Shabbetai ha-Cohen in Venice, 1719, featuring a Magen David in the upper righthand corner, as pictured in A. Yaari, *Hebrew Printers' Marks from the Beginning of Hebrew Printing to the End of the 19th Century* (Jerusalem, 1943), p. 61. (*Photo courtesy of the Library of Congress*)

10

Exit Pentagram

We have already indicated[1] why the name Magen David lent such great emphasis to the belief in the magical efficacy of the symbol and that the name's messianic allusion gave it an added dimension. We further saw that the name of Solomon, while occasionally attached to the hexagram, was more commonly associated with the five-pointed star, the pentagram (also called pentacle, pentalpha and pentangle). It had great currency in the world of magic, and many were the tales which exalted the power of the symbol.

Who among the Kabbalists would not have loved to emulate the king's power over Azza and Azzael, two fallen angels, or to be able to summon the archangel Michael, so that he might appear to them and say as, according to legend, he once said to Solomon: "Take the gift which the Lord Zebaot has sent you. With it you can control all the earth's demons, both male and female. But you must wear this seal of God, and the engraving of the seal is a pentalpha."[2]

The German poet-dramatist Goethe incorporated this tale into his *Faust*. The hero is visited by Mephistopheles, chief of the netherworld, and is informed by him that the pentagram on the door jamb hinders his exit. Faust asks:

The pentagram is troubling you?

Come, tell me, son of Hell,
How did you enter then and fool the spirits
If it has banning power?
How can a spirit be betrayed?

Whereupon Mephistopheles replies:

Look closely, 'tis not precisely drawn,
One corner, at the outer side,
Is, as you see, a little open.[3]

If magic power alone would have been decisive the pentagram might have won wider acceptance among the Jews. However, it had one major drawback: it was even more commonly used among non-Jews.

The five-pointed star had come to represent the heavenly bodies the wise men of the Christian Gospels had seen. It became popular in painting and, not surprisingly, in magic as well. The star did not, of course, have the emotional impact of the cross, yet it too became a clearly identifiable symbol evoking the history of Christendom.

But not there alone. Among the Celts too it was popular and was identified with their priestly caste, the Druids. Hence the name *Drudenfuss* or *Trutenfuss*, as it was often called in Germany.[4] In Germany, *Drude* came to mean witch,[5] and together with the second part of the word (*fuss*, German for foot) conveyed the image of secret charms, such as a rabbit's foot still does in our day.

At the dawn of modern times the pentagram was also called by its Latin name, *pes bubonis*, literally "owl's foot," and with this name as well as its German equivalent it was recorded by two contemporary sources as having adorned the flag of the Hungarian Jewish community of Ofen (Buda).

Two reports – one in German and one in Latin – describe the 1476 coronation and marriage of King Matthias and how on that occasion the Jews appeared with a red flag. It displayed a *Drudenfuss* (according to the German chronicler), a *pes bubonis* (according to the Latin source).[6] The latter describes specifically a five-pointed symbol which was enhanced by gold stars and a "golden Jewish hat." (One recalls at once the "Swedish" hat of the Prague flags. It has already been pointed out that its appearance on a flag, long before the Swedish invasion of Prague, is added proof that the hats in all these flags derive from the government's policy to have Jews set apart and identified by special attire.[7]) It is a pity that this flag did not survive, for it seems to be the only time that a pentagram served in an official capacity for a Jewish community.

But it is clear, especially in retrospect, that neither as *pes bubonis* nor as *Drudenfuss* was the pentagram likely to endear itself permanently to Jews. In Bavaria (and probably elsewhere as well) the Celtic origin of the sign was well remembered, and the way popular custom perpetuated such lore would hardly endear it to Jews. A nineteenth-century writer describes a Celtic deity in these terms:

> A woman's head with crown, and an oxen's horns and ears; between the horns the so-called popular Drudenfuss... well known in southern Germany and Switzerland.... At the beginning of the [nineteenth] century certain miners still had the habit of drawing the Drudenfuss with chalk on their doors, no doubt as a defense against evil spirits, especially witches.... This explains why the symbol, as a protective sign against demonic powers, continues to be seen among the people.[8]

But not among the Jews. This kind of magic, together with Christian religious usage, made the pentagram ineligible as a distinctive Jewish symbol. Even the venerable name of King Solomon could not secure for it a permanent place of affection among his own people. It exited for them when its major function as magic symbol was no longer important, and when Jews, stepping into the modern world, saw the pentagram in many gentile places around them. A uniquely Jewish function for the pentagram was out of the question, if indeed it had ever had a chance.

Among other nations the sign became and remained highly visible, and in time its magic background was forgotten. Thus today, more than forty countries display the pentagram on their national flags, among them the United States of America whose fifty states are represented by fifty pentagrams. Of all the flags of the world, only the flags of Israel and Burundi[9] display the hexagram.

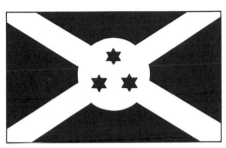

Flag of Burundi

NOTES

1 Above, ch. 5.
2 Ginzberg, *Legends*, vol. IV, pp. 152 ff.; sources in vol. VI, p. 292 f.
3 *Faust*, Part I, Scene 3.
4 See above, p. 34, where we discussed the application of this name to the hexagram, which in turn caused a vocal opposition to the claim that the Magen David had pagan origins.
5 The debasement of a proper ethnic term - as from Druid to Drude=witch - is frequent in linguistic history. To "jew" and to "welsh" came to stand for cheating; and to "french" for certain sexual practices.
6 Güdemann, vol. III, p. 667 note 6, quotes the Latin report by Schwandtner, as well as a German source, p. 166.

Güdemann errs, however, when he identifies the *pes bubonis* with the hexagram; p. 166 note 12.
7 See above, p. 54. The Latin source calls the hat *tyara*, and the German, *Judenhütt*. The Hungarian flag also featured the Hebrew inscription *Shema Yisrael*.
8 Cited by Löw, vol. 2 (1871), p. 142. Other popular usages are quoted in vol. 1 (1870), p. 213 note 238.
9 This flag with three hexagrams prominently displayed can be seen in *1987 Britannica Book of the Year* (Chicago, 1987), plate 3 following p. 576. I do not know the reason for this design but surmise that it has no connection to the Jewish symbol.

11

Toward a National Symbol

The year 1789 marked a watershed in the history of Europe. Shockwaves of the French revolution were felt everywhere, and Napoleon's subsequent march across the continent left indelible traces on the social fabric of Europe. Once begun, the future emancipation of the disenfranchised was a certainty, and while it took longer in some countries than in others its eventual sweep encompassed the western world. What started in Paris as a revolt of the middle class evolved in time into the universal recognition of the rights of workers, serfs and slaves.

Religion too was affected. Like other privileged institutions, the Christian Church tried to maintain its status and prerogatives as the "dominant religion." While it was willing to tolerate Jews (the primary religious dissidents), it was not ready to grant them rights. The eloquent Count Mirabeau scorned this recalcitrance:

> Dominant religion! May these tyrannical words disappear entirely from our legislation. For if you allow this term in the realm of religion, you will have to allow it everywhere else: you will then have not only a dominant religious cult but also a dominant philosophy and a dominant system. No! Justice alone shall dominate: the highest principle is the right of the individual. All else must be subordinate to it.[1]

Jews too were the beneficiaries of this development. In fact, from the very beginning of the debates about human rights, the emancipation of the Jews was at issue. The Jews'

presence in French society bestirred the advocates of freedom to enlarge their call and to encompass all humanity in its demands. Abbé Henri Grégoire and Count Mirabeau spoke about human rights and cited the depressed condition of the Jews, and a few generations later the American Negroes too would identify with the Jews in their search for liberation.

Beset by forces that had kept them inside visible or invisible ghettos and in legal subjugation, Europe's Jews were now touched by new hope. Redemptory movements erupted among them as they did among Christians. Hasidism, at first bitterly opposed, gained grudging acceptance from the old-line rabbinic establishment, while the Frankist leadership (offshoots of the Sabbatean movement) crossed the line that separated Judaism from Christianity and Islam. Jews were facing profound changes because the new age beckoned them with a promise of equality and freedom – something they had not experienced since their own commonwealth crumbled before the forces of the Roman legions.

The new era saw its dawning in France, but its first major consequence for the Jews occurred in Germany.[2] It was here that large numbers of them first stepped into the world of ideas and customs which until then had not concerned them. Though as individuals they could not as yet aspire to full civic equality, they sought the acceptance of Jewish legitimacy as their immediate goal. This, they felt, was now within their grasp.

Such communal aspirations were, of course, of no further interest to those who, having discarded their Jewish garb and language, decided to meld completely into the new environment, and if the price of admission was abandonment of the ancient faith and people, they were willing to pay it. A steady trickle of converts diminished the ranks of German Jews, but it remained a trickle only. The majority wanted to remain Jewish and were not hesitant to display their allegiance openly.

When the old walls came down, Jews marched into the world of the cross without an emblem of their own. In the ghetto they had left behind, such display had been unnecessary. Jewish identity in the Jewish quarter was self-evident and its synagogues did not need to be marked as Jewish places of worship. In the post-emancipation period, however, such identity was suddenly less discernible. Jews as individuals no longer wore yellow badges or pointed hats; these distinguishing marks were now generally recognized as oppressive. Proclaiming one's Jewishness in the religious sphere was not only permissible, it was, to the Jew, proof that equality was more than a vague promise. Quite naturally, therefore, the potential for full equality suggested that if one wanted to be Jewish in the same way that Christians were Christian, a symbol that would proclaim the ancient faith was highly desirable.

It was under such circumstances that the time was ripe for a commonly recognized Jewish insigne. Germany's Children of Israel – calling themselves "German citizens of the Jewish faith"[3] – were ready to identify themselves by a sign that would, like the cross, be a *religious* mark.

This does not mean that they now set out to search for one. The dynamics of emancipation worked subtly and below the level of consciousness. No assembly or committee designed a suitable symbol, and in any case, the Jewish people had no central body that could have organized such an enterprise. But Jews were ready to accept what was at hand and elevate it to common usage. The Magen David filled this role admirably.

It had already made considerable strides before the arrival of emancipation. Mystics and purveyors of magic had used it as a favorite symbol for amulets, and the prominence given it by leading communities had accorded it respectability.

Dutch snuff box, 1889 (2″ × 3.25″). From the collection of Dr. Fred Weinberg, Toronto. (*Photo by David Latchman*)

Clock, Vienna, Austria, late 19th century.
Joseph B. and Olyn Horwitz Collection, B'nai
B'rith Klutznick Museum, Washington, D.C.
(Photo courtesy of the museum)

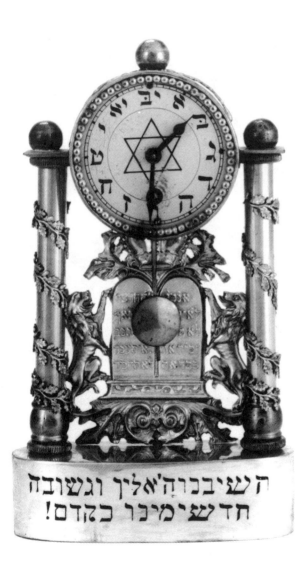

השיבכויה'אלין וגשובה
חדשי'מינו כקדם!

The name "Shield of David" had invested the sign with a redemptive dimension. Within fifty years after Emancipation – a very brief moment in history! – it established itself in the German cultural realm (in which Prague and Vienna occupied key places) as the major symbol of Jewish identity.

The new "German citizens of the Jewish faith" embraced the emblem with verve and vigor. A century before, the Magen David had appeared here and there;[4] now suddenly, in the 1800's, its use became widespread. The famous Oppenheimer pictures which portrayed the German-Jewish family of that age frequently included the Magen David as a window design. Synagogues, Torah mantles, ark curtains and other religious objects created at this time were now frequently adorned with it.

From Germany the sign's popularity spread to Eastern Europe's Jews who, amid reactionary social and political conditions, followed the emancipation of the German

Jews with avid interest, and the Magen David now became popular as a symbol of hoped-for liberation in the Russian realm. At a slow but steady pace the emblem made its way among this largest Jewish population bloc in the world.

The sign traveled westward as well when European Jews brought it with them to America. It was now seen in Italy too, but amongst Sefardim in North Africa it was still largely unknown.[5]

One may speculate how much the non-representational character of the Magen David contributed to its surging acceptance in the nineteenth century. The two equilateral triangles convey no image of any object, and the post-emancipation period emphasized the spiritual rather than the national identity of the Jew. The menorah, depicted on the Arch of Titus, evoked the memory of nationhood lost; the Magen David did no such thing – it proclaimed Jewish identity in a general way. One could read into the symbol whatever one wanted, and this very vagueness became a prime asset. It was about to become the universally recognized Jewish counterpoint to the Christian cross.[6]

NOTES

1 Cited in author's *The Case for the Chosen People* (Garden City, 1965), p. 119, with further references.

2 The North American experience will not be discussed here, for at the beginning of the nineteenth century only a relatively small number of Jews lived in the United States and Canada. Those who subsequently arrived brought with them the ideas and experiences of Europe. Neither will we consider the environment which Jews in Islamic countries faced; there, they lived either under the sway of a medieval Turkish sultanate or under British and French colonial rule where European ideas found entry.

3 *Deutsche Staatsbürger jüdischer Religion.* Jews described themselves in this fashion, emphasizing their religious rather than their national selfhood.

4 Thus, a Torah curtain of 1720 was decorated with it; a wedding stone showed it in 1756; and in 1770 we find it on a plate used for the ceremony of *eruv hatserot* ("mixing of domains," a legal device which joined certain dwellings for the Sabbath to permit the carrying of objects between them, something that otherwise would be forbidden; a plate of food would serve as a symbol of this joining). But as late as 1779 a Passover plate still featured the pentagram. See Wischnitzer-Bernstein, p. 55; F. Landsberger, *A History of Jewish Art* (Cincinnati, 1946), pp. 79, 62.

5 See above, p. 36 note 9.

6 That would become most evident when, at the beginning of the twentieth century, the Red Magen David Society was established in Switzerland, because Jews found the cross of the Red Cross societies unacceptable. See *Oesterreichische Wochenschrift*, 1915, p. 673.

12

Interpretive Intermezzo

As the process of the Magen David's acceptance unfolded, the natural curiosity of scholars and lay persons was aroused: Was this really David's shield? What was the meaning of the geometric configuration? Did it convey a deeper symbolism which the Jewish people had subconsciously understood and now, at last, brought to the level of conscious identification? Such and more were the questions asked, and the answers given ranged over the whole field of historical inquiry. In turning to some examples it will be well to keep in mind that we are here in an area of highly speculative social and religious history.

The ubiquity of the sign from ancient days on testifies first of all to its attraction as a decorative design with cosmic meanings, as was the case also with the circle, triangle, rectangle, pentagram and swastika.[1] The attraction of the hexagram was probably enhanced by the fact that it pointed both upward and downward at the same time and thereby was fit to evoke cosmic associations.

Two of the more imaginative studies of such presumed associations were made with regard to the Cheops pyramid in Egypt and the Solomonic temple in Jerusalem. The former was built at Giza (near Cairo) in the 26th century B.C.E., the latter in the tenth century B.C.E.

During the First World War, Fritz Nöthling (a German) was interned in Australia. Someone asked him to explain the origin of bushel and quart. From this inquiry Nöthling was taken farther and farther afield and eventually ended up studying the stone chest in the Cheops pyramid which he discovered to be an example of certain measuring principles. Through the studies of Max Eyth on this subject he was led to a re-appraisal of the nature and design of the pyramid itself and found its dimensions to reveal that

Cheopspyramide

Diagram from Nöthling, *Die Kosmischen Zahlen der Cheopspyramide* (Hamburg, 1960). A Magen David can be discerned at C-b-d/C'-b'-d', another at S-H-I/S'-H'-I'. Part of the text which accompanies this diagram translates as follows: "It would be worthwhile to examine more closely the many mysterious threads through which the Magen David is tied to the mystic and cultural life of the peoples of all times. . ."

the earth's revolution around the sun (or vice versa, as then believed) lasted 365 days, 5 hours, and 40 minutes. Moreover, the distance of sun from earth was also derivable from the building's structure. The key to these calculations, Nöthling found, was a hexagram with two non-equilateral triangles which fitted the pyramid's interior perfectly.

He reasoned that this figure was a cosmic symbol known to the Egyptians and therefore probably to the Hebrews. He published his study after the war.[2]

That the Hebrews were cognizant of some of these principles and used the hexagram architecturally was in fact a thesis proposed a few years earlier. Its proponent was a Benedictine monk, Odilo Wolff, whose monastery was located – where else? – in Prague. His calculations arrived at the conclusion that Solomon's temple in Jerusalem was built in proportions derived from the hexagram.[3]

Others addressed themselves to the intrinsic meaning of the Magen

David. They suggested that the sign appeared to hold heaven and earth in balance, and that its dual nature spoke of contrast and its whole of unity – a tension especially explored by the mystics.[4]

A combination of Magen David and swastika comprise the symbol of the "Raëliau" movement, a cult founded in France in 1973. It considers the hexagram a sign of the infinity of space and the swastika of the infinity of time. (In appropriating these figures and combining them into one, the cult chooses to overlook their modern antipodal significance.)

Another aspect of the symbol's meaning was explored by Carl Jung in his study of symbolism:

> A great many of the eastern meditation figures are purely geometrical in design; they are called yantras. Aside from the circle, a very common yantra motif is formed by two interpenetrating triangles, one point-upward, the other point-downward.

Symbol of the Raëliau movement as displayed in its literature.

Traditionally, this shape symbolizes the union of Shiva and Shakti, the male and female divinities, a subject that also appears in sculpture in countless variations. In terms of psychological symbolism, it expresses the union of opposites – the union of the personal, temporal world of the ego with the non-personal, timeless world of the non-ego. Ultimately, this union is the fulfilment and goal of all religions: it is the symbol of the union of the soul with God.

The two interpenetrating triangles have a symbolic meaning similar to that of the more common circular mandala. They represent the wholeness of the psyche or Self, of which consciousness is just as much part as the unconscious.

In both the triangle yantras and the sculptural representations of the union of Shiva and Shakti, the emphasis lies on a tension between opposites. Hence the marked erotic character of many of them.[5]

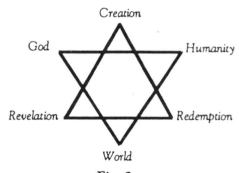

Fig. 3

Star of Redemption

Franz Rosenweig's Star of Redemption, as pictured in Peli, *Shabbat Shalom: A Renewed Encounter with the Sabbath* (1988), p. 26. (*Courtesy of B'nai B'rith Books*)

An important Jewish interpreter of the symbol was Franz Rosenzweig, one of the twentieth century's most influential Jewish philosophers. He entitled his major work *Star of Redemption*, in which he perceived the Magen David as a symbol of the structure of Judaism.[6]

He begins by postulating a division of existence between God, world and humanity. Since the latter two are no farther from each other than each one is from God, only an equilateral triangle will satisfy this reality. He calls this the "pre-natural" triangle of creation which points upward, while the second, the "natural" one, is pointing downward. Above is the Source of Creation, below the result. The Magen David is a parable of being which speaks of creation, revelation and redemption. Its intertwined triangles mirror the gathering of its elements into One Path.

Rosenzweig wrote his *Star* during the First World War when he was a German soldier at the Balkan front. The symbol had by then already

become representative of German Jewish existence, and he saw its design as vindicating the essence of the Jewish faith. For him, the Magen David was a paradigm of Judaism, but he did not of course suggest that its history was thereby explained.

Others did, however, though not with any success. One student of the subject wrote: "If one can throw light on the meaning of the sign, the development into a symbol will be newly elucidated."[7] He should have said: "If we understand what people saw in the sign and why they did so, we can better follow the history of its acceptance." Present in many cultures, it became known to European Jews as a mystic symbol; amulet magic gave it currency and messianic hope its appeal; Prague afforded it respectability and Emancipation provided it with momentum. The average Jew of the nineteenth century who was not a student of history came to believe what students of the Kabbalah and their successors had

taken for granted, namely, that the sign had been David's own – and this folklore aided its wide acceptance.

It had made its way without any common resolution of a representative Jewish body. This did not occur until the end of the century when the Zionist movement adopted the Magen David.

NOTES

1 The swastika, also called "hooked cross" (*Hakenkreuz*) was a variant of the simple cross and as such is classified as *crux gammata*. It was, and is, popular in India. See *Encyclopaedia Britannica, Macropaedia* (15th ed., 1975), vol. IX, p. 712. H. Vorwhal discussed the swastika's function in the Semitic realm; see *Monatsschrift für die Geschichte und Wissenschaft des Judentums*, vol. 66 (1922), pp. 9-11.

2 *Die kosmischen Zahlen der Cheopspyramide* (Stuttgart, 1921).

3 *Der Temple von Jerusalem* (Vienna, 1913).

4 See above, pp. 9-10. A few examples from the large literature on this subject are: A. Jeremias, *Handbuch der altorientalischen Geisteskultur* (Berlin, 1929); J. Michaelis, "Das Davidsschild," *Der Morgen* (1934), pp. 80 ff; and the numerous articles by Max Grunwald who occupied himself extensively with this question. See, e.g., *Jahrbuch für jüdische Volkskunde* (1923), pp. 377, 389, 440, 463, 478; Appendix to Breier (cited above); *Jahrbuch für jüdische Geschichte und Literatur*, vol. 4 (1901), pp. 123, 234; M. Güdemann, *Monatsschrift*, vol. 60 (1916), p. 135. See also literature quoted in Scholem's article in *Encyclopaedia Judaica*, sub "Magen David."

5 *Man and his symbols*, (London, 1964), pp. 240-241. See photo of *yantra* above, p. 18.

6 First published in Frankfurt in 1921. English translation by W.W. Hallo (New York, 1970).

7 S.T. Nussenblatt in *Yivo Bleter*, vol. 13 (1938), pp. 460 ff. He also believed that the symbol represented the tribes of Israel; his view is properly criticized by S. Kalmanovitz, *ibid.*, pp. 583 ff.

13

Flag of Zion

When the First Zionist Congress met in Basel in 1897, the Magen David was already well recognized in Europe, but it was not as yet *the* universal symbol. The Jews of North Africa did not know it, and in North America too the earliest Jewish immigrants of Sefardic and German background did not identify with it nor use it in their synagogues. Not until the middle of the nineteenth century did the German Jews bring it with them, and not until the mass migrations of East European Jews after 1881 did the sign achieve wide popularity in the New World. As in Europe, it was now increasingly found on ritual items and houses of worship. It would take the Zionist movement to establish its national character as well.

As one would expect, the emergence of the Magen David as the official insigne of Zionism was not a straightforward process. Moreover, even the question of how the blue-and-white flag was adopted by the movement cannot be answered simply. The matter is of great interest to our inquiry, for when the Magen David became part of Zion's flag it cleared the last major hurdle in the way of universal recognition.

How was the Zionist (and now Israel's) flag created, with its white background, blue stripes on top and bottom, and the Magen David in the center? The question engenders the kind of controversy that has swirled around many inventions and innovations. In fact, it is said of three individuals and one group that the Zionist flag originated with them. The four contenders were:

1) The *Hovevei Zion* (Lovers of Zion), who originated in Russia and inspired the first modern settlements in Palestine, chief among them Petach Tikvah, Rishon le-Zion, Zikhron Yaakov, and Rosh Pinnah. The claim is made that *in 1880-1881* they designed a banner which became the forerunner of today's flag, and that it flew at the third anniversary observance of Rishon le-Zion in 1885.

2) Jacob Baruch Askowith is said to have designed the flag and dis-

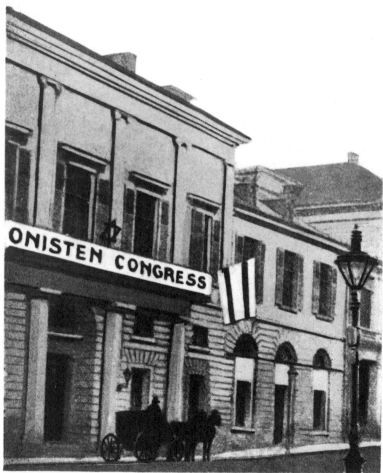

The Stadtkasino in Basel, Switzerland, 1897, where the first six Zionist Congresses were held, as pictured in de Haas, *Theodor Herzl* (1927), facing p. 176. (*Photo courtesy of the Library of Congress*)

played it *in 1891* in Boston.

3) Isidor Donn, an artist living in London, said he designed the banner *in 1893*.

4) David Wolffsohn, Herzl's close associate and his eventual successor as the president of the Zionist movement, asserted that he himself had ordered the flag to be created and displayed at the First Congress, in the *summer of 1897*.

(Theodor Herzl, founder of political Zionism, had drawn his own proposal for a *different* flag in 1897, just before the First Congress. More about this later.)

These claims are not easy to sort out, and of course there is the possibility that some of the putative creators, or even all of them, arrived at the design independently of each other, and that some, or all of them, made a contribution toward having it become the official insigne of the movement.[1]

The Congress opened in the Stadtkasino in Basel on August 29, 1897. Fourteen years later

Wolffsohn remembered how it all started.

On the instructions of Herzl, our leader, I proceeded to Basel to make arrangements for the Congress.... One of the many problems with which we had to deal... was to decide what flag should drape the hall. The question troubled me considerably. Obviously, since we had no flag, we would have to create one.

First, what colors should we select, and second, on what basis should we select one at all, seeing that the Jewish people are expressly forbidden to make use of likenesses and images? Suddenly, I got a brainstorm: we already had a flag: the blue-and-white of the *tallit* [2].... We only had to unfurl it before the eyes of the Jewish people and the world at large! Accordingly, I ordered a blue-and-white flag with the Shield of David in the center... And when finally it waved over the hall no one raised any questions about it or expressed surprise. It seemed perfectly natural.[3]

This recollection is further embellished by a report that Wolffsohn held up the *tallit* and said: "This is our national flag!"[4] No mention here, however, of the Magen David.

Alas, it appears that Wolffsohn's testimony is based on faulty memory. A black-and-white photograph of the meeting hall's interior shows no flag at all, though another – taken of the entrance to the building – does portray a white banner with (presumably blue) parallel stripes, *though not with a Magen David in the center*. A Magen David did appear *above* the sign which proclaimed "Zionisten Kongress."[5]

A somewhat different recollection is supplied by Dr. Isidor Schalit, who was Herzl's secretary and assisted him with the Zionist journal *Die Welt*. In a series of lengthy

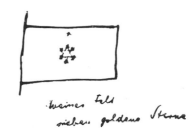

Herzl's first design for the Zionist flag, 1896, with notes from his diary: "Here's the sketch of our flag: white field, seven golden stars." The white was to represent the "new, pure life," and the seven golden stars represented his ideal of the seven-hour working day. From Herzl, *Altneuland* (reprinted Haifa, 1960), p. 206. *(Photo courtesy of the Library of Congress)*

letters written in the early 1950's (and found in the Central Zionist Archives in Jerusalem), he described his own recollections of the First Congress and cited contemporary witnesses, among them Julius Löwy of *Davar* and Bertold Feiwel, director of the Keren Hayesod.

Schalit had been sent by Herzl to Basel to make advance arrangements for the first Congress. According to him, the flag that Wolffsohn recollects was not in evidence, but rather another one which Schalit himself had ordered. It was blue and white and was hung by him from the balcony of the Stadtkasino, to the applause of passers-by. The photograph in the book by de Haas may have been of the banner which Schalit claims to have made. The argument will have to rest there – in any case, at the First Congress the Magen David was not yet joined to the flag.

There is no dispute over the design of the badges which were issued to the delegates. They wore small azure-colored seven-cornered emblems with twelve stars in red and gold, bearing the legend (in German): "The only solution of the Jewish question is the establishment of a Jewish state." Above this they pinned a blue-and-white rosette with the Magen David. Together these served as the official badges for the delegates.[6]

In sum, the Magen David and the blue-and-white flag had not as yet been joined; the Magen David did, however, appear on the front of the building; and the delegates wore a rosette with the Magen David, while their badges were seven-cornered and had twelve stars.

The stars and the blue-white banner came from the Hovevei Zion whose flag was blue and white with twelve stars, to represent the twelve tribes of Israel. They also had another emblem which they wore when they assembled for meetings in their home communities: a badge which displayed the Magen David with the word ציון (Zion) in the center.[7]

There is no question then that the Magen David was prominently displayed at the Congress, and Herzl's new Zionist journal, *Die Welt*, featured it in its masthead.

That design came directly from Herzl's pen.[8] In his diary, Herzl writes of a Jewish flag as early as 1895. He thought of a Magen David with six stars at the six corners, and a seventh star placed above it. It was his hope that the Jewish state would pioneer a seven-hour work day. Later on he altered the design somewhat. On his son Hans' seventh birthday he gave him, he wrote in his diary on June 10, 1898, "Zion's flag. A shield of David with six stars inside the six triangles. The seventh above. In the middle the Lion of Judah after a drawing of the painter, Okin."

It is worth noting that this entry into his diary was made almost a year *after* the First Congress and shortly before the Second one took place. Clearly, the now traditional banner had not as yet been finalized. In his mind the Zionist flag

should consist of a Magen David, seven stars and a Lion of Judah. Herzl had good reason to think that way, for this was indeed the badge which delegates had worn the year before, in Basel. He wanted the design of the badge to be transferred to the banner itself.

Herzl had been introduced to the Hovevei Zion design by Col. Albert Goldsmid in London, some nine months before the First Congress. In his diary of November 25, 1896, Herzl notes that Goldsmid had shown him the Hovevei Zion flag. The next day he met with Dr. Hirsch, their secretary, who asked Herzl whether he would accept their flag. Herzl showed him his own and suggested that the Hovevei Zion banner could serve for religious or synagogue purposes "for those who want it," while as a national, secular banner he preferred his own model.[9]

Four months later the differences still persisted. Herzl gave a lecture which was chaired by Goldsmid.

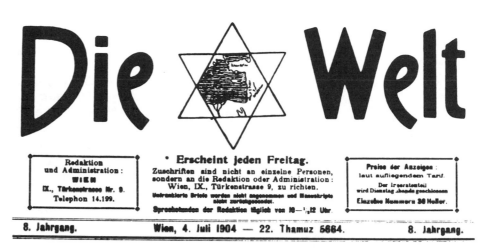

Masthead of *Die Welt* (*Vienna*) with the Magen David design. This issue, published on the fourth of July 1904, announced the death of Theodor Herzl. Pictured in Herzl, *Altneuland* (reprinted Haifa, 1960), p. 205. (*Photo courtesy of the Library of Congress*)

Herzl's alternate suggestion for the design of the Zionist flag: a Magen David with a lion of Judah and seven stars, as pictured in Herzl, *Altneuland* (reprinted Haifa, 1960), p. 26. (*Photo courtesy of the Library of Congress*)

Feier zum
100. Geburtstag von
Dr. Theodor Herzl
1860-1960
BASEL 15. Mai 1960

Basel postmark showing Herzl's Zionist emblem, issued to commemorate the centennial of Herzl's birth. Pictured in Herzl, *Altneuland* (reprinted Haifa, 1960), p. 26. (*Photo courtesy of the Library of Congress*)

The latter wrote about it to de Haas:

> I had the Hovevi [sic] banner displayed at the lecture and naturally referred to the seven-starred banner proposed by Dr. Herzl and stated that I preferred our flag to his, as it embraced the religious and historical idea, whereas his introduced social questions about which there were differences of opinion, and had no historical association and was an imitation of the flag of the American republics.[10]

Goldsmid was right in that Herzl, who had no traditional background, did have social ideals in mind, though it is dubious that the American flag served him in any wise as a model. In his diary he remarked wistfully, "We now have a flag problem."[11]

At the time of the First Congress, the problem had not yet been resolved and therefore contrasting designs were in evidence. The blue-white banner over the outside of the entrance hall and the twelve-starred delegates' shield represented the religious-traditional ideas of the Hovevei Zion; and the Magen David above the banner as well as on the delegates' badges may be said to reflect, at least in part, Herzl's idea and the assumption that the Shield of David was generally acceptable.

Thus, a picture collage showing the delegates to the First Congress, with Herzl's image large in the center, was embellished at each of the four corners with a Shield of David, and each had a special design. In the center of one the Hebrew word ציון appears – shades of Hovevei Zion and B'nai Zion;[12] in another, a lion à la Herzl's proposition; a third has the Magen David embellished with Herzl's seven stars; and the fourth carries the letters להב, an acronym for לשנה הבאה בירושלים (next year in Jerusalem).[13]

The collage reveals that for a time following the First Congress

the designs were still in competition, but a year later, at the Second Congress, the conflict was resolved by way of a compromise. The Magen David that in 1897 had loomed above the blue-white flag was joined with it in 1898, and neither Herzl's seven stars nor the Hovevei Zion's twelve made it into subsequent history.

That leaves the question of how and by whom the compromise was effected. Was Wolffsohn's basic recollection correct, that he simply went ahead and did it? Possibly, though it is difficult to imagine that he would have done it without Herzl's agreement. Still, having no other witness, we must conclude that it was Wolffsohn who was responsible for displaying the now familiar flag (though with Herzl's lion included), only that some years later when he wrote about it, he confused the Second Congress with the First. (When and how the lion was later removed is not clear.)

But had Wolffsohn, though he described his inspiration as a brain-

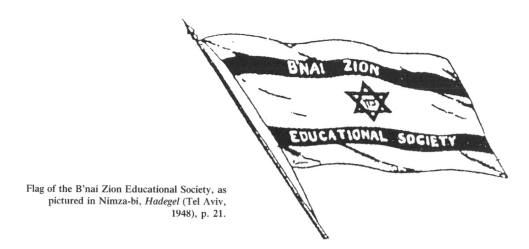

Flag of the B'nai Zion Educational Society, as pictured in Nimza-bi, *Hadegel* (Tel Aviv, 1948), p. 21.

storm, seen such a flag anywhere, or heard of it from someone? Perhaps. In that case, we have two candidates for having created the model.

De Haas relates that he had seen a banner of this kind in 1893 in London. It had been designed by the artist Isidor S. Donn who said that he had used the *tallit* for design and color. Apparently, the additional use of the Magen David had suggested itself to him because the sign was by now widely displayed in conjunction with Jewish

items.

But the same flag was attested already two years earlier, though on the other side of the ocean. The maker of the flag was Jacob Baruch Askowith who designed it for the B'nai Zion Society of Boston. Testimony of his contribution comes from two sources: an account in a Boston newspaper of the time, and a recollection by his daughter, Dora. She published her memoirs fifty years later.[14] The flag, she wrote,

consisted of a white cloth, about a yard long, upon which were painted two horizontal blue stripes enclosing a Shield of David. In the center of the latter was painted in blue the Hebrew word מכבי (Maccabee). Exhibited along with the flags of other nations and placed beside the Stars and Stripes, it was subsequently kept at Zion Hall.

A slightly altered form of the banner, made by a firm on Tremont Street, was carried by members of the [B'nai Zion] society on Columbus Day 1892, in the parade which marked the four hundredth anniversary of the discovery of America. The word ציון (Zion) however, was substituted for the original מכבי (Maccabee), and the name of the society was added on the blue stripes. A smaller replica, made from the original by the writer's two sisters, Mrs. Nathan Ulanov of New York and Mrs. Samuel Schein of Brookline, Mass., was carried beside it by members of the B'not Zion Society, a group of some twenty-five young women organized by the writer's eldest brother Elias Askowith. After the parade, the larger flag was encased in a cabinet and hung on the wall of Zion Hall. Not until recent years was its subsequent history discovered. It was then learned that after the hall was closed, Elias Askowith took it into safe custody, and upon his death in 1905 it was interred with him. A reproduction appeared on souvenir cards distributed in Boston at the semi-jubilee of the B'nai Zion Educational Society on March 18, 1916.

The authenticity of this account is supported by contemporary reportage. The exhibit of the flag at B'nai Zion hall[15] was described in *The American Hebrew* on July 24, 1891. The carrying of the flag at the Columbus Day parade was reported by the *Boston Globe* on October 23, 1892. Under the caption "Flag of Judah" it observed that the banner "which was carried alongside the American flag, was the first of its kind ever seen in Boston." Also, Askowith's assertion that the Zionist flag was first displayed as the official emblem at the Second Congress, in 1898, is correct, though she does not specifically claim that the B'nai Zion flag served as the model.[16]

Were Donn and Askowith godfathers of the flag as we know it today? Or was it the Hovevei Zion, a number of whose members attended the Congress? Or Wolffsohn? Or all of them, because the combination of the old *tallit* with the more recent but broadly popular Magen David was simply an idea whose time had come? Perhaps the last surmise comes closest to the truth, and Wolffsohn may have been the one who, by displaying it at the right time in the right place, brought about its public acceptance.

Henceforth, the flag served as the commonly (though not officially) agreed upon symbol of the movement.

That official adoption did not come until 1933, when the 18th Zionist Congress passed a resolution which declared that "by long tradition, the blue-and-white flag is the flag of the Zionist organization and the Jewish people." It became the official banner of Britain's Jewish Brigade in World War II and, to no one's surprise, was acknowledged by the Provisional Council of the new State of Israel as its national ensign. The date was October 28, 1948.

After Israel's first parliament was elected it passed a Flag and Emblem Law and the Magen David now represented the Jewish people reconstituted in its own land.[17]

But the menorah was not forgotten. For centuries it had helped to identify Jews and their tradition and then had lost its supremacy to the Magen David. Now, in Israel, it was again given an honored place.

The Shield of David was seen on Israel's flag, and the menorah became in every other way the official emblem of the state.

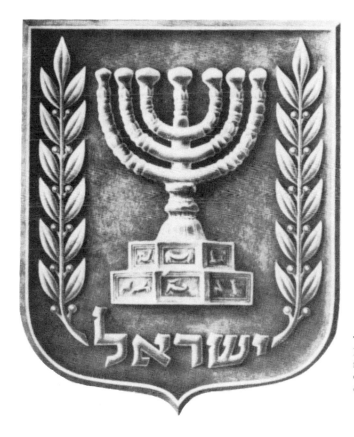

The official emblem of the State of Israel featuring the menorah, pictured in *Encyclopaedia Judaica*, vol. 11, col. 1366. (*Photo courtesy of the Library of Congress*)

Emblem of the Bilu Society as pictured in *Encyclopaedia Judaica*, vol. 4, col. 1000. (*Photo courtesy of the Library of Congress*)

NOTES

1 It is also claimed that the "blue and white" colors were first proposed by a German-Jewish poet, Ludwig August Frankel, who wrote of them in his poem "Ahnenbilder" in 1864.

2 The traditional prayer shawl. In Wolffsohn's day its stripes were usually blue; nowadays they are often black or even multicolored.

3 Wolffsohn's article appeared first in *Ha-Tsefirah* and was reprinted in *Sefer Ha-Kongress*, ed. A. Jaffe (Tel Aviv, 1932), p. 214.

4 Mitchell Rosenberg, *The Story of Zionism* (New York, 1946), p. 239, who gives no source for this statement which Wolffsohn himself apparently did not remember.

5 Jacob de Haas, *Theodor Herzl* (Chicago-New York, 1927), facing p. 176.

6 *Ibid*, p. 167.

7 Letter of Mordecai ben Hillel Ha-Kohen to S.D. Levontin, St. Petersburg (now Leningrad), Dec. 3, 1881; quoted by Franz Kobler, *Jüdische Geschichte in Briefen aus Ost und West* (Vienna, 1938), pp. 453-454.

 A member society of the Hovevei Zion, The Bilu, had created a symbol of its own (though it was not a flag): a Magen David with two quotations. One was in Hebrew: "The smallest shall become a clan; the least, a mighty nation" (Isaiah 60:22). The other was in Latin and cited Sallust (86-34 B.C.E.): "What is small will grow through concord." See *Encyclopaedia Judaica*, vol. 4, col. 1000.

8 Herzl, *Tagebücher* (Berlin, 1923), vol. I, p. 323.

9 *Tagebücher*, vol. I, pp. 323, 325. The meeting was attended also by the Rev. I. Singer and Asher Myers Hirsch.

10 De Haas, p. 82. On the Hovevei Zion design, see A. Drujanov, *Ketavim letoledot Hibbat Zion* (Tel Aviv, 1942), vol. III, pp. 699, 711 note 3.

11 Vol. I, p. 597 (entry for March 11, 1897).

12 Of whom more below.

13 *Encyclopaedia Judaica*, vol. 16, cols. 1165-1166.

14 Dora Askowith, *Jewish Social Studies*, vol. 6 (1944), pp. 55-57.

15 Located at 170 Hanover Street in Boston.

16 The Zionist historian, A. Bein, tried to correct Askowith's account in a subsequent issue of *Jewish Social Studies*, vol. 6 (1945), p. 150. But his rejoinder is based on faulty premises. Equally unfounded and presented without proof are Michael Simon's ascriptions, *Encyclopaedia Judaica*, vol. 6, col. 1337.

17 May 24, 1949; see *Iton Rishmi*, 1948-1949, nos. 2, 32, and 50.

14

Mark of Death – Mark of Life

Though the Zionist movement did not at once capture the imagination of Jews everywhere, its presence was soon felt in Jewish communities around the globe and its incorporation of the Magen David on its flag helped to make it the best known of all Jewish symbols. Still, the sign had not as yet become the property of every individual Jew as well. In a perverse way that was brought about by the bitterest enemy the children of Israel had ever experienced.

Long before the Nazis came to power in Germany,[1] they had vilified the Jews at public gatherings and, with unremitting viciousness, in their publications. Among these, Julius Streicher's *Der Stürmer* easily outdid the rest. Lurid tales of alleged Jewish depravity, especially in matters sexual, titillated its readers, and vitriolic cartoons fixed in their minds the demonic image of the Jew as seen by the editor: hooked nose, bulging eyes, thick lips dripping with saliva, money bags under his arms, and a pure Aryan girl about to be violated by the lascivious monster. And frequently, just to make sure the good German reader would get the point, the Magen David was added to the pictorial masterpiece to point out the Jewish identity of the offender.

For Germans as well as Jews had come to see the *Judenstern* (Jewish Star) as the recognized symbol of Jewish identity.

April 1, 1933, was the day on which the Nazis organized a nation-wide boycott of Jewish businesses. They scrawled *Jude* (Jew) or painted the Star on every Jewish store window. On that day the Magen David was transferred from the *Stürmer, Angriff* and *Völkischer Beobachter*[2] to the public realm in the broadest sense. The Jewish badge had not as yet been resuscitated – that was to come later – but figuratively speaking, it was already affixed to every Jew.

Propaganda cartoon from *Der Stürmer* (date unknown).

Three days later Robert Weltsch, editor of Berlin's Zionist journal, *Die Jüdische Rundschau*, addressed his readers in a memorable editorial entitled "Wear the Yellow Badge with Pride."[3] I lived in Berlin during those days and I remember the emotion with which we read this remarkable challenge.

The Jews, Weltsch wrote, were singled out for contempt and contumely. No matter; as long as Jews knew their own worth and had a proper measure of self-esteem, the ignominy heaped upon them by the outside world could not touch them. It might restrict their physical existence but not their souls. The Jewish spirit was beyond the reach of the enemy.

I remember how deeply we were moved by the message. Weltsch could not gauge the full sweep of evil that in the years to follow was to engulf our people, but he helped us at the time to salvage our humanity and our pride. The oppression produced in many of us a new and fervent identification with our

people, religion and culture.

There were others, of course, who had tried to evade their Jewishness, but the Nazis had forced it on them again. These persons, Weltsch wrote, now had to admit membership in the Jewish people, "not because of an inner conviction, not because of loyalty to their people, nor because of their pride in a magnificent history and in the noblest human achievements," but because their enemies affixed to their property or their persons an identifying sign – either a Magen David or the word *Jude* or both.[4]

The yellow badge of which Weltsch spoke was then still a metaphor, before the isolation of the Jews turned to systematic slaughter. The Nazis had smeared a Magen David on Jewish business establishments, but the actual badge – affixed first to arms and afterwards to breasts and backs – was yet to come. When it did, introduced by special edicts, it was imposed by the Germans wherever they encountered Jewish populations. Its effect

JÜDISCHE RUNDSCHAU

Tragt ihn mit Stolz, den gelben Fleck!

שאוהו בגאון, את הטלאי הצהוב", מאמרו של רוברט ולטש בביטאון הציוני"

1933 באפריל 4 , *Jüdische Rundschau*

Heading of the editorial "Wear the Yellow Badge with Pride" by Robert Weltsch in the *Jüdische Rundschau*, April 4, 1933, as pictured in Gutman, *Fighters Among the Ruins: The Story of Jewish Heroism During World War II* (1988), p. 47. (*Photo courtesy of B'nai B'rith Books*)

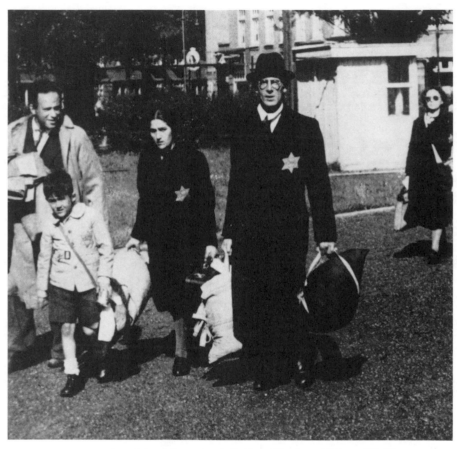

Jews wearing badges, from Schoenberner, *Der Gelbe Stern* (Hamburg, 1961), p. 117. (*Photo courtesy of the Library of Congress*)

was profound. The Star isolated the Jews and in time marked them for death. The Nazis' systematic attack on Jewish survival did in fact begin with the introduction of the badge.[5]

It was first tried out in Poland, shortly after the Germans had occupied the country. They had invaded it on September 1, 1939, and on October 24 the Jews of Wloclawek were instructed by Oberführer Cramer of the SA[6] to wear a yellow triangle. Shortly thereafter, in Cracow, Governor Wächter decreed that all Jews, or children of a Jewish father or mother, had to be clearly designated as such:

> As a distinguishing mark an armband is to be worn on the upper arm of their clothes as well as on the outer garments, which is to show the Zion's Star on a white background.[7]

In time, Governor General Hans Frank introduced a Jewish badge for all of Poland. The edict was published in the official gazette.[8]

Beginning with the 15th of September 1941, Jews who have reached the age of six are forbidden to appear in public without a Jewish Star. They are also forbidden to leave their community without written permission by the police, or to wear decorations, medals or other insignia.

This does not apply to the Jewish partner of a mixed marriage if there are children who are not considered as Jews or if their only son was killed in the war, or to the Jewish wife of a childless mixed marriage, as long as she remains married.

Usually the word Jew was inscribed in the center of the Star (which was shaped as a Magen David), in the language of the occupied land: *Jude, Juif, Jood.*

The star, a high-ranking Nazi in France made clear, would be "one more step to the final solution of the Jewish problem in all the occu-

Der Distriktschef von Krakau

ANORDNUNG
Kennzeichnung der Juden im Distrikt Krakau

Ich ordne an, dass alle Juden im Alter von über 12 Jahren im Distrikt Krakau mit Wirkung vom 1. 12. 1939 ausserhalb ihrer eigenen Wohnung ein sichtbares Kennzeichen zu tragen haben. Dieser Anordnung unterliegen auch nur vorübergehend im Distriktsbereich anwesende Juden für die Dauer ihres Aufenthaltes.

Als Jude im Sinne dieser Anordnung gilt:

1. wer der mosaischen Glaubensgemeinschaft angehört oder angehört hat,
2. jeder, dessen Vater oder Mutter der mosaischen Glaubensgemeinschaft angehört oder angehört hat.

Als Kennzeichen ist am rechten Oberarm der Kleidung und der Überkleidung eine Armbinde zu tragen, die auf weissem Grunde an der Aussenseite einen blauen Zionstern zeigt. Der weisse Grund muss eine Breite von mindestens 10 cm. haben, der Zionstern muss so gross sein, dass dessen gegenüberliegende Spitzen mindestens 8 cm. entfernt sind. Der Balken muss 1 cm. breit sein.

Juden, die dieser Verpflichtung nicht nachkommen, haben strenge Bestrafung zu gewärtigen.

Für die Ausführung dieser Anordnung, insbesondere die Versorgung der Juden mit Kennzeichen, sind die Ältestenräte verantwortlich.

Krakau, den 18. 11. 1939. gez. *Wächter*
 Gouverneur

Governor Wachter's edict from Schoenberner, *Der Gelbe Stern* (Hamburg, 1961), p. 31. (*Photo courtesy of the Library of Congress*)

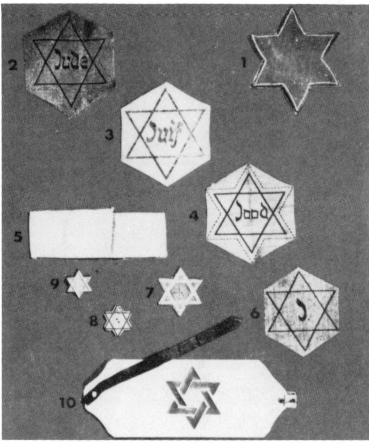

Badges Jews were required to wear during the Nazi occupation of Europe:
(1) Bulgaria, part of Poland, Lithuania, Hungary, part of Greece;
(2) Germany, Alsace, Bohemia-Moravia; (3) France; (4) Holland;
(5) part of Greece, Serbia, Belgrade, Sofia, (6) Belgium;
(7) Slovakia; (8) Bulgaria; (9) Slovakia; (10) part of Poland,
East and Upper Silesia. From the Archives at Yad Vashem, Jerusalem,
as pictured in *Encyclopaedia Judaica*, vol. 4, col. 72. (*Photo courtesy of the Library of Congress*)

pied territories of the West."[9] And last but not least, it played its somber role in the Nazis' ultimate deception when in fact it became the mark of death. In Belzec it loomed over the gas chamber, masquerading it as a bath. And Adolf Eichmann, the executor of the Final Solution, assured Jewish leaders in Hungary that "he would not tolerate the harming of Jews for wearing the yellow star."[10]

Yet, as the fires of Belzec and Auschwitz burned down, the Final Solution turned out not to have been final. Jews, though diminished in numbers, found their way back into life, and with them went their ensign. It had for a while been a symbol of death; now it would forever be changed into a symbol of new life and hope.

Three years after the Nazi nightmare came to an end, the State of Israel was proclaimed. The Magen David now flew over the Jewish nation, itself brought back to life after two millennia.

NOTES

1 On January 30, 1933.
2 The latter two among the most widely read Nazi newspapers.
3 "Tragt ihn mit Stolz, den gelben Fleck." Weltsch died in 1982, in England, where he had become the editor of the *Leo Baeck Yearbook*.
4 A description of the impact of the April 1 boycott can be found in Martin Gilbert, *The Holocaust* (New York, 1985), pp. 33 ff.
5 This point is made by Gerald Reitlinger, *The Final Solution* (New York, 1953), p. 53. See also below, footnote 9.
6 *Sturmabteilung*, often referred to as "Brown-Shirts," in contradistinction to the SS (*Schutzstaffel*) or "Black-Shirts."
7 Gerhard Schoenberner, *Der gelbe Stern* (Hamburg, 1961), p. 31.
8 *Reichsgesetzblatt*, vol. I, p. 547. See also *Das Sonderrecht für die Juden im NS Staat*, ed. Joseph Wolk (Heidelberg-Karlsruhe, 1981), p. 347. The German text reads as follows: *Polizeiverordnung über die Kennzeichnung der Juden.*
 Ab 15.9.41 ist es den Juden, die das sechste Lebensjahr vollendet haben, verboten, sich in der Öffentlichkeit ohne einen Judenstern zu zeigen. Juden ist es verboten, ohne schriftliche, polizeiliche Erlaubnis ihre Wohngemeinde zu verlassen und Orden, Ehrenzeichen oder

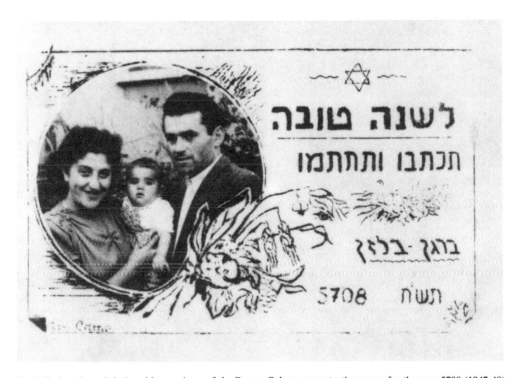

Rosh Hashanah card designed by survivors of the Bergen-Belsen concentration camp for the year 5708 (1947-48). From Bloch, *Holocaust and Rebirth* (1965), p. 145. Reproduced by permission of the World Federation of the Bergen-Belsen Associations, Inc. (*Photo courtesy of the Library of Congress*)

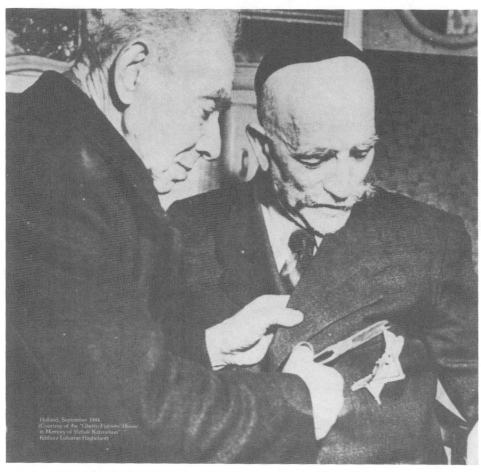

Holland, September 1944.
(Courtesy of the "Ghetto Fighters' House
in Memory of Yizhak Katznelson",
Kibbutz Lohamei Haghetaot)

Cutting off the badge, Holland, September 1944. Photo on exhibit at "Ghetto Fighters' House in Memory of Yizhak Katznelson," Kibbutz Lohamei Haghetaot, reproduced from Beth Hatefutsoth, *Return to Life* **(Tel Aviv, 1965), frontispiece.**

sonstige Abzeichen zu tragen. Dies gilt nicht für die in Mischehe lebenden jüdischen Ehegatten, sofern Abkömmlinge aus der Ehe vorhanden sind, die nicht als Juden gelten oder der einzige Sohn im Krieg gefallen ist, ferner nicht für die jüdische Ehefrau bei kinderloser Mischehe während der Dauer der Ehe.

9 Michel R. Marrus and Robert O. Paxton, *Vichy-France and the Jews* (New York, 1981), p. 235. On the badge in occupied France, Belgium and Holland, as well as on Italian and local opposition, see pp. 234 ff.; also Léon Poliakov, *L'Étoile jaune* (Paris, 1949).

10 Gilbert, p. 663.

EPILOGUE

Star's Journey

The Magen David had in the twentieth century become the clear and undisputed symbol of the Jewish people. It had risen to this pre-eminence from humble beginnings: ubiquitous as a universal decoration, protective device, or sign of hope, friendship, or whatever the particular tradition in which it appeared had assigned to it. It entered the realms of mysticism and magic where it acquired increasing popularity.

In the fourteenth century, the Jews of Prague were issued a flag with the sign which was more and more called the Magen David. It was the first time the symbol served in an official capacity. Slowly it made its way from Prague and Vienna to other European cities and lands, until Emancipation spurred Jews on to grasp hold of a symbol that would identify them in their religious singularity. Germany was the first country in which European Jewry tasted the heady wine of liberty, and here the symbol rapidly spread to fill a cultural-religious vacuum, and the Zionist movement, led by German Jews, made it part of its national ensign.

Little more than a generation later, in the German realm now dominated by the Nazis, all Jews were issued the symbol as a compulsory mark of identity which set them aside for discrimination, persecution and, eventually, for slaughter. But that was not the end of the matter, for when the purposes of the enemy were at last thwarted and a remnant of the people survived the horror, this very remnant helped to place its badge upon the flag of Israel, to make it in truth a badge of pride. Shortly after the war, when the Holocaust stood revealed in all its starkness, Gershom Scholem, the greatest student of the Magen David, wrote:

> Under this sign they were murdered; under this sign they came to Israel. If there is a fertile soil from which symbols draw their meaning, it would seem to be given here.
>
> Some have been of the opinion that the sign which

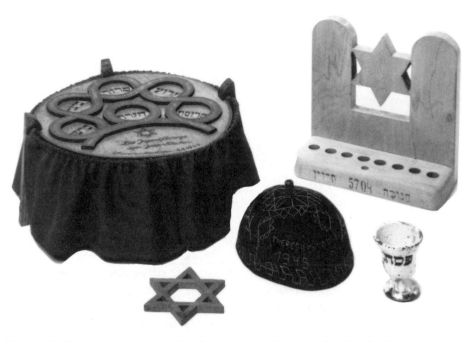

Ceremonial objects made by inmates of the Terezin concentration camp, from *The Precious Legacy: Judaic Treasures from the Czechoslovak State Collections*, (*Photo courtesy of* SITES)

marked the way to the gas chambers should be replaced by a sign of life. But it is possible to think quite the opposite: the sign which in our days has been sanctified by suffering and dread has become worthy of illuminating the path of life and reconstruction. Before ascending, the path led down into the abyss; there the symbol received its ultimate humiliation and there it won its greatness.[1]

The Magen David had made its way through uncharted and sometimes murky waters; it had been used for noble as well as evil purposes. It had emerged alone among many symbols, a star of hope that had survived the night.

All Jews now put it on their shields; it has become their *magen*, their protection. It belonged to David in legend and folklore, and under his name it became the property of the whole Jewish people.

NOTES

1 *Messianic Idea*, p. 281.

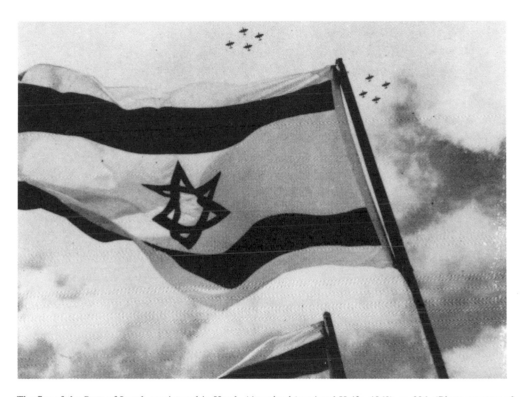

The flag of the State of Israel, as pictured in Herzl, *Altneuland* (reprinted Haifa, 1960), p. 206. (*Photo courtesy of the Library of Congress*)

SELECTED BIBLIOGRAPHY

Cohn-Wiener, Ernst, *Die jüdische Kunst* (Berlin: M. Wasservogel, 1929).

Goodenough, Erwin H., *Jewish Symbols in the Greco-Roman Period*, 13 vols. (New York: Pantheon Books, from 1953 on).

Grunwald, Max. His writings on Jewish folklore and notations on the Magen David are scattered through many journals, e.g. *Jahrbuch für jüdische Geschichte und Literatur*, 1901, p.123 ff., 234; *Jahrbuch für jüdische Volkskunde*, 1923, pp. 377, 389, 440, 463, 478.

Günzburg, David and Stassoff, W. [also Stasov, V.V.], *L'ornement hébreux*, (Berlin: n.p., 1905). [This is a later edition of *Ornamentation des anciens manuscris hébreux* (St. Petersburg: Renn & N. Netschaieff, 1886).]

Herzl, Theodor, *Tagebücher*, 3 vols. (Berlin: Jüdischer Verlag, 1922-1923).

Lion, Jindrich and Lukas, Jan, *Das Prager Ghetto* (Prague: Artis, 1959).

Loukomski, George K., *Jewish Art in European Synagogues* (London: Hutchinson & Co., 1947).

Löw, Leopold, *Graphische Requisiten und Erzeugnisse bei den Juden*, 2 vols. (Leipzig: G. Leiner, 1870).

Markham, Sir Clements, ed., *Libro del Conoscimiento* (London: Hakluyt Society, 1912).

Schoenberner, Gerhard, *Der gelbe Stern* (Hamburg: Rütten, 1961).

Scholem, Gershom, "The Star of David: History of a Jewish Symbol," in *The Messianic Idea in Judaism* (New York: Schocken, 1971), pp. 257-281. (For further biographical details on this pathbreaking essay, see above, Prologue, note 2.) See also Scholem's article "Magen David" in *Encyclopaedia Judaica* (Jerusalem: Keter, 1972, vol. 11, pp. 687-697.

Singermann, Felix, *Die Kennzeichnung der Juden im Mittelalter* (Berlin: L. Lamm, 1915).

Wischnitzer-Bernstein, Rachel, *Symbole und Gestalten der jüdischen Kunst* (Berlin: S. Scholem, 1935).

Yaari, Avraham, *Daglei ha-madpisim ha-ivriyim* (Jerusalem: Hebrew University Press Association, 1944.)

INDEX

Abraham ben Shabbetai ha-Cohen 68
Abulafia, Abraham 38
Afendopolo, Caleb 29-30
American Hebrew, The 94
Amsterdam 62-63, 67
Arama, Isaac 39
Arch of Titus 65,79
Askowith, Dora 93-94
Askowith, Elias 94
Askowith, Jacob Baruch 87, 93
Austria 13-15

Basel, Switzerland 87-91
Belzec 102
B'nai Zion Society of Boston 93-94
B'not Zion Society 94
Baalbeck, Syria 13
Bacchus Temple 13
Badges, use on police & sherriff 21
Bar Kochba coin 26-27
Bologna Synagogue 42
Boston Globe 94
British usage in Africa
 on one-penny coin 22
 on flag of Nigeria 22
Bronze Age 25

Canada, Toronto
 Church of Redeemer 22-23
 City Hall, E.J. Lennox 23
 Library of Osgoode Hall 23
 Timothy Eaton Memorial Church 23
Celts 71-72
Charles IV 51
Cheops pyramid 10, 81-82
Christian cross 62, 76-77
Christian shrines, use of
 hexagram in 15-16
Consistoire 34-35
Constantinople 66
Copts, Egyptian 16
Cosmographia Universalis 20
Cramer, Oberführer 100
Cresquez lo Juheu 20, 30
Cyprus 7

David, King of Israel 10, 28, 30, 38-44, 49, 65
De Haas, Jacob 92, 93
Der Stürmer 97
Diament, Paul 63
Die Jüdische Rundschau 98
Die Welt 89-90
Donn, Isidor 88, 93

Ecclesiasticus (Ben Sira) 42
Egypt 7, 9-10, 81-82
Eichmann, Adolf 102
Eybeschütz, Jonathan 43-44
Eyth, Max 81

Feiwel, Bertold 90
Ferdinand II, Emperor 53-54
Fettmilch, Vincent 63
First Zionist Congress 87-93
Flag and Emblem Law, Israel 95
Flags and banners, usage of hexagram on:
 Burundi 73
 Europe, North Africa, Asia Minor (in medieval times) 18-20, 30
 Israel 73, 95
 Nigeria (British colony) 22
 Zionist Congress 87-95
Foà family 66-68
 Foà, Gad ben Samuel 67
 Foà, Isaac 67
 Foà, Nathaniel 67
 Foà, Tobias 67
Frank, Hans 100
Frank, Jacob 43
Frankfurt 63
Frankists 44, 76
Freer Gallery of Art, Washington, D.C. 17
French War Department 34-35

Gans, David 55
Germany 3, 16-17, 76-79, 97-100
Gezer 25

Goethe, Johann Wolfgang von, use
 of pentagram in *Faust* 71
Goldsmid, Albert 92
Golem 29, 56-57
Goodenough, Erwin H. 7-8, 25, 27
Gordon, Judah Leib 34
Great Seal of the United States 21
Greco-Roman period 7, 25
Greece 7
Güdemann, Moritz 36, 43

Hasidism 76
Hats as Jewish emblems 53-55
 (see ''Swedish hats'')
Herzl, Theodor 88-91
Holy Roman Empire 51
Hovevei Zion (Lovers of Zion) 87,90-94
Hungary 63

India 17
 Muslim & non-Muslim uses in Yantra design 17, 83
Islamic realm 17
Israel 73, 87, 95
Italy 27, 33, 67

Jaffe, Israel 67
Japan (Ise) 18
Jerash 25
Jewish Brigade (of Britain, WWII) 95
Judah Hadassi 29-30
Judah Loew ben Bezalel (Maharal) 55-57
Jung, Carl 83

Kabbalah 47, 56-57, 85
Kfar Joseph & Beth Shearim 25
Kfar Nachum (Capernaum) 26
Khazars 53
Kolb, Leon 13-14
Kristallnacht 3

Lezer-Aron 61
Lion as Jewish symbol 33, 40-41, 66
Lisbon 66
Lyre as Jewish symbol 65
Löw, Leopold 34
Löwy, Julius 90

Magen Abraham 68
Magen Druid 34
Masonic imagery 21-22
Megiddo 25
Meisel, Mordechai ben Sumuel 53
Meisel Synagogue 53, 55
Menorah as Jewish symbol 40, 65, 95
Menorah Psalm 39, 41
Mesopotamia 7, 17,
Mohr, Joseph 61-62
Münster, Sebastian 20

Nazi(s) 97, 99-102, 105
Nöthling, Fritz 81-82

Oppenheim, David 55-56

Palestine 7, 25
Pentagram 9, 37-38, 71-73
Persia 7, 33
Phillippines 16
Poland 100
Portugal 63
Prague 51-57, 61-63, 66, 78
Provisional Council of Israel 95
Psalm 121 41

Raëliau symbol 83
Reubeni, David 42
Romans, Rome 15, 33
Rosenzweig, Franz 84-85
Rosette, "banal" 7-8
Rudolf II 53-54, 56
Russia 79

Sabbatai Zevi 43-44
Sabbateans 43-44, 76
Schalit, Isidor 89-90
Schedel, (World History, 1493) 20
Schein, Mrs. Samuel 94
Scholem, Prof. Gershom 1, 3-4, 43,52-53, 63, 105
Second Zionist Congress 93
Seal of Solomon 10, 29, 37-38
Seder Tefillot 66
Sefardim 79
Sefer Raziel 49
Semites 13
Solomon, King of Israel 10, 29, 30, 37-38, 73

Solomonic Temple, Jerusalem 81-82
Star of Redemption 84
Stein, Leopold 38
Streicher, Julius 97
"Swedish hats" 54-55, 62, 72
Sudanese antiquities 17

Thomson, Secretary Charles (U.S.A.) 21
Turkish siege of Vienna 14-15
Tyre 9

Ulanov, Mrs. Nathan 94
United States Congress 21

Vienna 14-15, 61-63, 78, 105

Weltsch, Robert 98
Winkler, H.A. 49
Wloclawek, Poland 100
Wolff, Odilo 82
Wolffsohn, David 88-90, 93, 94

Yantra design 17, 83

Zionism (Switzerland) 24
Zionist movement 23, 35-36, 87-95,97-98, 105